IMAGES
of America

SALADO

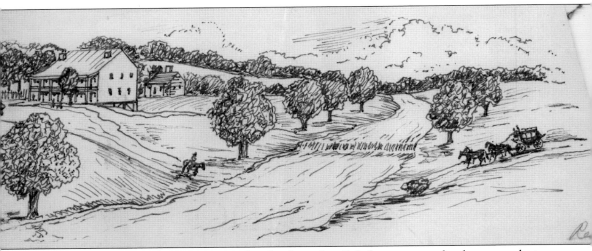

This drawing by an unknown artist evokes the days when Salado was an overland stagecoach stop along the Chisholm Trail. The stagecoach, approaching Salado Creek with an anticipated stop at the Shady Villa Hotel, created a sense of excitement and adventure. The stagecoach represents Salado's frontier beginnings and deep sense of history. (Salado Historical Society.)

ON THE COVER: The Shady Villa Hotel was the scene for the Trolley Line Mass Meeting of 1906–1907.

IMAGES
of America

SALADO

Mary Harrison Hodge and
Charlene Ochsner Carson

ARCADIA
PUBLISHING

Published by Arcadia Publishing
Charleston, South Carolina

Printed in the United States of America

Library of Congress Control Number: 2013946446

For all general information, please contact Arcadia Publishing:
Telephone 843-853-2070
Fax 843-853-0044
E-mail sales@arcadiapublishing.com
For customer service and orders:
Toll-Free 1-888-313-2665

Visit us on the Internet at www.arcadiapublishing.com

To all Salado historians—past, present, and future

CONTENTS

ACKNOWLEDGMENTS

Salado has always been blessed with people who have recognized the rich history of the village and who have carefully and lovingly recorded that history for future generations. We are grateful to those historians for sharing their memories, their photographs, and their written accounts of everyday events that have become the recorded history of the village.

The images in this publication appear through the courtesy of several individuals and institutions. The authors appreciate all those who have searched for and contributed special photographs. Their names appear alongside their contributions. Several photographs came from collections. Among those are the C.B. and Mary Hodge collection, the Sophia Vickrey Ard collection, the Central Texas Area Museum Collection (CTAM), and the Salado Historical Society Collection (SHS).

Many of the photographs regarding the Robertson family and the Robertson Plantation appear courtesy of the Robertson Plantation Archives and Sterling R. Ambrose. The authors thank the Robertson family for allowing us to browse through their family scrapbook and select the images that best tell the story of the Robertson Plantation and its relationship to Salado.

We also appreciate our Arcadia Publishing editor, Laura Bruns, for the kind and gentle way in which she guided us through the writing and production process.

Historical facts for this book were taken from the following sources: *Salado Driving Tape Tours*, an unpublished manuscript by Patricia Lawshe Barton; *Salado Creek and Its Mills*, an unpublished manuscript by Patricia Lawshe Barton; *History of Salado, Texas*, compiled by MaryBelle Brown and Bill Kinnison; *Building His Kingdom, 140-Year History 1864-2004, First Baptist Church, Salado, Texas* by Charlene Ochsner Carson; *My Memories of Salado* by Linda Friedrich Cawthon; *Salado and Bell County, Texas, A History in Postcards* by Mary Harrison Hodge; *Salado, Texas, Its History and People* by Felda Davis Shanklin; *History of Bell County* by George W. Tyler; *Salado, Texas Frontier College Town* by Charles A. Turnbo; *Salado Country Cooking* by the Monday Club of the Salado United Methodist Church; and *Story of Bell County Texas Volume I and II*, by the Bell County Historical Commission.

INTRODUCTION

The Village of Salado has an interesting historical background. In the latter part of 1859, Salado came into existence as a school center, with only two or three small stores. Prior to the Civil War, Salado was one of only three towns in Bell County, Texas. Because of its location on the overland stage route, Salado had a post office as early as 1852, and it is the only town in Bell County to have a working Southern-style plantation as a neighbor. The purpose of this book is to take the reader on a photographic journey through the rich, diverse history of Salado.

The journey begins with the Gault site, a historic treasure in Salado's backyard. This archaeological site is located about seven miles southwest of Salado on FM 2843. It is thought to be one of the sites of the earliest humans in the Americas.

Modern settlement of Central Texas began in 1827, when Sterling Clack Robertson, the *empresario* of Robertson Colony, brought hundreds of pioneer families to this area. The colony covered an area 100 miles long and 200 miles wide along the Brazos River. In the 1850s, Robertson's son, Col. Elijah Sterling Clack Robertson, and Colonel Robertson's wife, Mary E. Dickey, selected Salado as the site for their home. They built what is historically known as the Robertson Plantation. Among the remaining structures associated with the main house are the barn and the slave quarters. This book includes photographs depicting life on this 1850s ranch.

The picturesque Village of Salado lays to the east of the Robertson Plantation. In 1859, Colonel Robertson was instrumental in founding a college for the residents of Salado. This private school, one of the first colleges in the state, operated on its original charter from 1860 until 1880. The availability of a college education set Salado apart from other towns in Central Texas. When the college was founded, a village emerged. Many families came to Salado specifically because of the educational opportunities offered by the college. The development of the college and the three disastrous fires that contributed to its closing are shown pictorially in this book.

The main street of Salado was laid out in 1838 as the Old Military Road. Later, it became an overland stage route through Central Texas and then was a branch of the Chisholm Trail. The need to accommodate travelers and cowboys driving their herds to Northern markets was met by the construction of a simple, two-story, somewhat primitive wood frame building known as the Shady Villa Hotel. Later, this simple building would become one of Salado's best-known landmarks. Today, it is known as the Stagecoach Inn.

In its earliest days, Salado's Main Street was lined with businesses that catered to the needs of an agriculture community. There was a general mercantile store, a grocery store, a bank, a grain and feed store, a cotton gin, and service stations.

Salado Creek, which runs through the middle of town, is a beautiful spring-fed creek that lent the village its name. Salado Creek has been designated as Texas's first natural landmark by the Texas Historical Commission. The marker proclaiming this honor was dedicated at the Main Street crossing of the creek on May 26, 1968, with Lt. Gov. Preston Smith in attendance. The creek does have its charm and beauty, but the residents of Salado have learned that it has two personalities. The creek has its peaceful, calm nature and its frisky, destructive nature.

Many of the early settlers of Salado were military men, physicians, and lawyers who built homes to reflect their status in life. They wanted their homes to have style and function, and they seemed to prefer the symmetry, proportions, and details of the Greek Revival style of architecture. This book's photographic tour of these historic homes will, in some instances, offer a glimpse of the interior of the homes and the families who lived within. Many of these early homes still stand on their firm foundations of native stone.

The pictorial journey continues with a tour of Salado's churches and schools. Each church has its own story to tell. The early churches began with a single group of believers meeting on the banks of Salado Creek or in the chapel of Salado College. More recent congregations were established as people felt a need to assemble in groups of worshippers of shared beliefs and convictions.

The tradition of excellence continues in Salado's schools today. Over 150 years after the founding of Salado College, families continue to move to Salado so their children can receive a quality education. Fond memories are associated with Salado's old redbrick school, where many of Salado's residents attended from the 1920s through the 1960s.

The photographic tour concludes with a showing of some of the town's flavorful and colorful events. Salado has a long history of annual celebrations, which have been enjoyed by thousands. The village has hosted antique shows, arts-and-craft shows, car shows, home tours, bed-and-breakfast tours, golf tournaments, Christmas strolls, the gathering of the Scottish Clans, and a variety of parades supporting various causes and events.

Today, Salado is a village in transition. However, in the midst of growth and change, the village is striving to keep its rustic charm, its sense of peace and tranquility, and its country style of gracious living. The authors' purpose is to keep Salado's history alive and intact.

One

PREHISTORIC SALADO AND THE GAULT SITE

Salado is a small community located in a rural part of Bell County. It is situated midway between Waco and Austin. Long before white settlers came into the area, Indians hunted and camped along the freshwater streams running through the rich, fertile fields. The Gault site, a 75-acre archaeological treasure located about seven miles southwest of Salado, offers physical evidence that there was Indian activity in the Salado area long before the first white man ever came to this part of Central Texas.

The Gault site, named for a local landowner, was discovered in 1929, around the same time as the Clovis site in New Mexico. The Gault site was one of the major areas of activity for the Clovis people in North America and contains relics that are at least 14,000 years old. The Clovis people, nomadic mammoth hunters who traveled from Siberia to Alaska across the Bering Strait, are thought to be the first people to enter the Americas. Evidence suggests that, when the Clovis people arrived at the Gault site, they stayed for long periods of time and that the site was occupied by several generations of the Clovis people.

There is also evidence at the site of a culture older than Clovis. Archeologists who have excavated below the Clovis levels have discovered chips and flakes produced by a different culture. Research is under way on a possible pre-Clovis culture.

To date, the Gault site has produced more than a million artifacts, which have been organized, cataloged, and prepared for future study. This amounts to about 60 percent of all the excavated materials from all of the Clovis sites in North America. The Gault site is an active archaeological research dig whose findings will continue to expand and enrich understanding of the everyday lives of the ancient people who once lived in Central Texas.

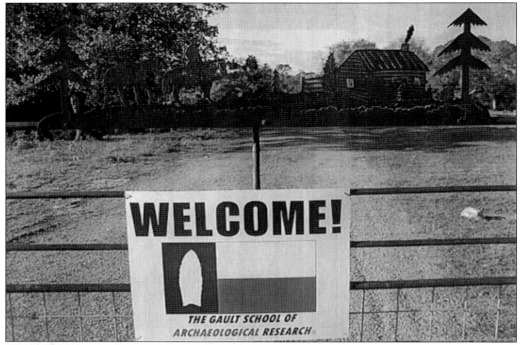

Welcome to the Gault site, an archaeological dig outside of Salado. This site was first investigated in 1929 by Prof. James E. Pearce of the University of Texas. It continues to be an active dig. (Gault School of Archaeological Research.)

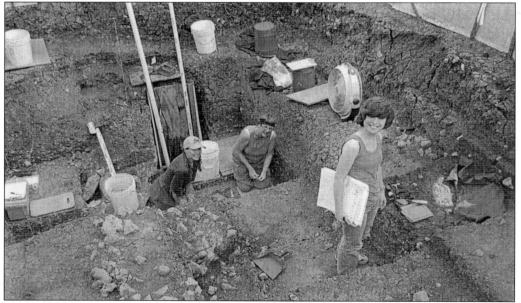

The site is being worked by a Gault staff member (left), a volunteer (center), and a Texas State graduate student. At one time, the owner of the property let pay-to-dig souvenir collectors dig at the site. Today, all digging is done under the supervision of the Gault School of Archaeological Research in San Marcos, Texas. (Gault School of Archaeological Research.)

Clovis points are named after the city of Clovis, New Mexico, where examples were first found. These distinctive spear points are among the best archaeological evidence for early settlements in North America. The scale shown at the bottom of the photograph indicates these arrowheads to be about three centimeters in width. (Gault School of Archaeological Research.)

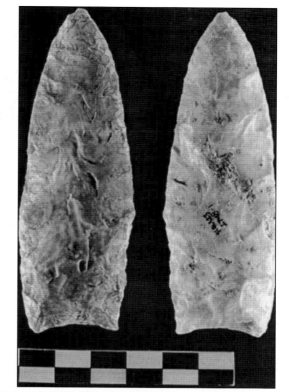

This incised stone is an example of the earliest provenienced art in the Americas. Field specimens are cataloged carefully and their original locations are documented. Location and context are important elements of archaeology. An artifact found at a gravesite has a different meaning than an artifact found in one's backyard. (Gault School of Archaeological Research.)

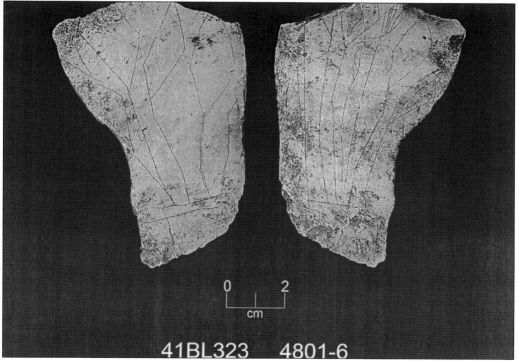

41BL323 4801-6

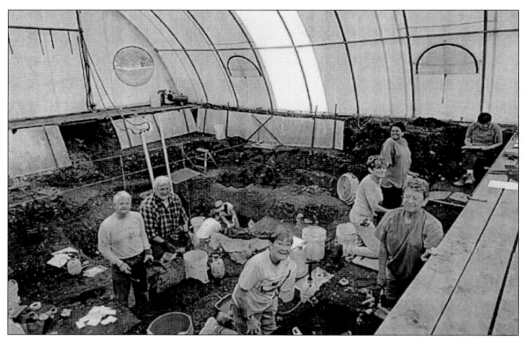

The Gault site is a rich archaeological dig, drawing groups of archaeologists from around the country. The group seen here came from Virginia. The dig indicates that when the Clovis people came to the area, they stayed for long periods of time and that they returned to the site for a period of 400 years. Each layer of the dig reveals new information about its former inhabitants. (Gault School of Archaeological Research.)

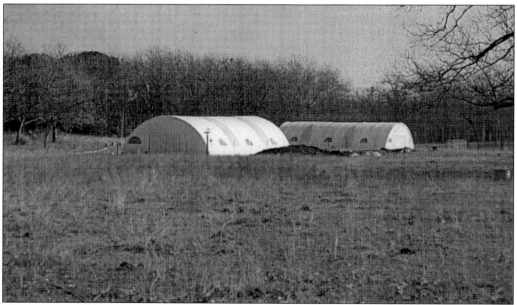

The excavation shelters shown in this photograph protect the dig site and the volunteers from the harsh Central Texas weather. Shelters also help secure the site. (Gault School of Archaeological Research.)

12

Two

THE ROBERTSON COLONY

AND

ROBERTSON PLANTATION

Colonization of Texas began in the early 1800s, when contractors, or *empresarios*, obtained land grants from the Mexican government for the purpose of bringing white settlers into what is now Central Texas.

In 1834, Maj. Sterling Clack Robertson, who had been in Texas as early as 1825, became the agent of the Nashville Company. The company would later become known as the Robertson Colony. The boundaries of Robertson's Colony embraced an area 100 miles wide and 200 miles long, centered on present-day Waco. For his part in inducing families to settle in his colony, Robertson received approximately 23,000 acres for every 100 families who settled in the colony. Robertson was successful in enticing a total of 600 families to come to Central Texas, which entitled him to more than 138,000 acres. He also established a townsite in present-day Falls County, but eventually, he retired to Robertson County, where he lived until his death in 1842.

After his father's death, Col. Elijah Sterling Clack Robertson, who was living and working in Austin as an attorney, came to the Salado area to maintain the colony that his father had established. In his personal correspondence to family members, Colonel Robertson indicated that he was weary of practicing law and wanted to enjoy life in the country as a planter. Soon after arriving, he began construction on what is historically known as the Robertson Plantation. Colonel Robertson built the house between 1856 and 1860 for his new wife, Mary E. Dickey Robertson. The house is a stately, 22-room Classical Revival structure with a Southern plantation flavor. At the time Robertson built his house, it is reported that his Bell County holdings consisted of approximately 23,000 acres and 15 slaves. He also had a large herd of livestock, including horses and cattle. Among the remaining structures associated with the main house are the barn and slave quarters. This home has served several generations of Robertsons and remains in the family as a working ranch.

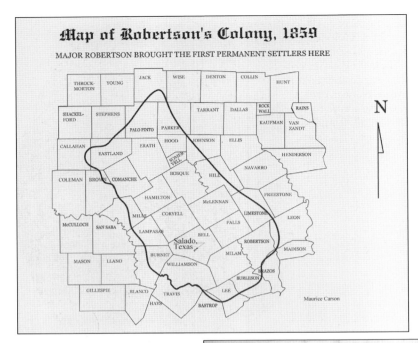

Map of Robertson's Colony, 1859

MAJOR ROBERTSON BROUGHT THE FIRST PERMANENT SETTLERS HERE

Maurice Carson

The Robertson Colony was established by Sterling Clack Robertson on a land grant from Mexico. The colony, situated in Central Texas, covered an area 100 miles wide and 200 miles long. All or part of 30 Central Texas counties, including Bell County, have been formed from the colony. (Maurice Carson.)

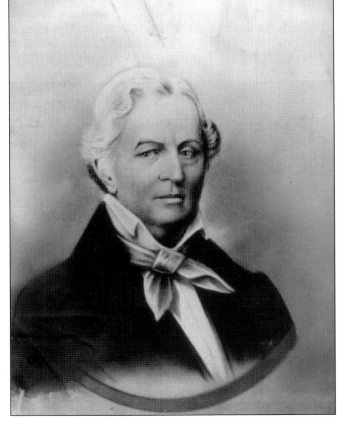

Maj. Sterling Clack Robertson, an *empresario*, soldier, and statesman, brought settlers to the Robertson Colony. He was a captain of a Texas Ranger Company and a signer of the Texas Declaration of Independence, as well as guarded Army supplies at the battle of San Jacinto. Major Robertson died in 1842 and was buried in Robertson County. In 1935, his remains were removed to Austin and interred in the Texas State Cemetery. (CTAM.)

Col. Elijah Sterling Clack Robertson (1820–1879) was a settler in his father's colony. Colonel Robertson moved to Salado in 1853 with his second wife, Mary Elizabeth Dickey. Together, they constructed their Robertson Plantation home near Salado, Texas. Robertson was a Texas pioneer, patriot, soldier, jurist, and one of the founders of Salado College. He died in 1879 and is buried in the family cemetery on the plantation. (CTAM.)

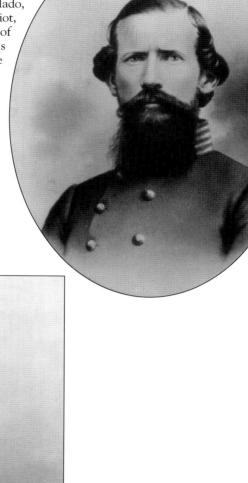

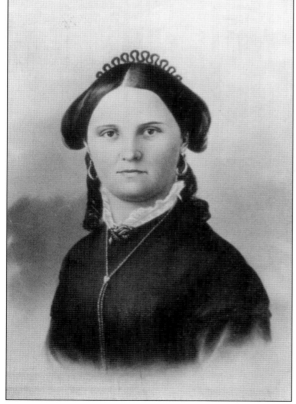

Mary Elizabeth Dickey Robertson (1834–1882), daughter of Samuel and Sophia Ann Parker Dickey, married Elijah Sterling Clack Robertson in November 1852 in Austin, Texas. At the time of their marriage, Colonel Robertson had two young children, Sterling Clack, age three, and Eliza Medora Susan, less than a year old. Eventually, the couple would have 12 more children. Mary Elizabeth died in 1882 and was buried next to her husband in the Robertson family cemetery. (CTAM.)

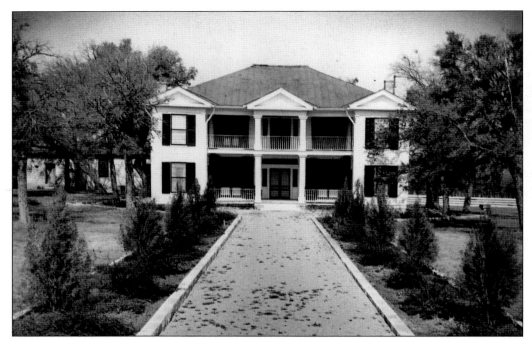

The Robertson Plantation home was built in the Greek Revival style. The design was brought from the East as settlers began populating western states. This 1860s home was listed as the Col. Elijah Sterling Clack Robertson Plantation in the National Register of Historic Places (NRHP) in 1983. The household consisted of Colonel Robertson, his wife, five children, his mother and father-in-law, an overseer, a stock herder, and a guest. (The Lena Armstrong Public Library, Belton, Texas.)

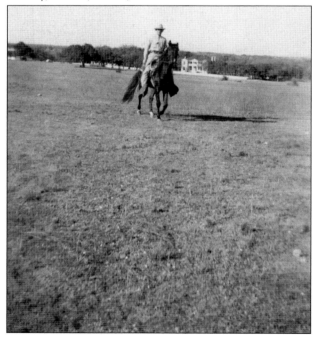

Sterling Robertson Sr., grandson of Col. E.S.C. Robertson, rides Chief Cloud, his favorite horse, in the south pasture of the ranch. The plantation home is in the background. Horses have always been an important part of the ranch. Present owners use horses to trail ride and work the ranch. (Robertson Plantation Archives.)

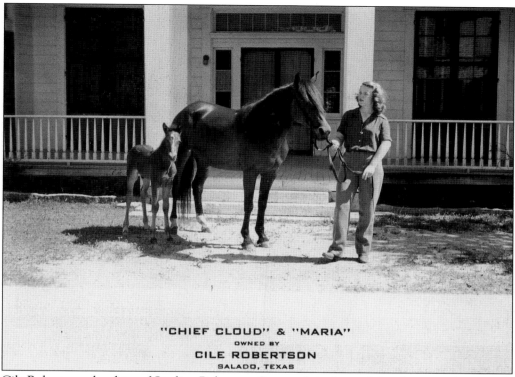

"CHIEF CLOUD" & "MARIA"
OWNED BY
CILE ROBERTSON
SALADO, TEXAS

Cile Robertson, daughter of Sterling Robertson Sr., stands in front of the plantation home with Chief Cloud and colt Maria. The colt had the ability to open any gate on the plantation. Cile enjoyed many happy days on the ranch and recalls many relatives returning to the ranch to reaffirm their identities as Robertsons. (Robertson Plantation Archives.)

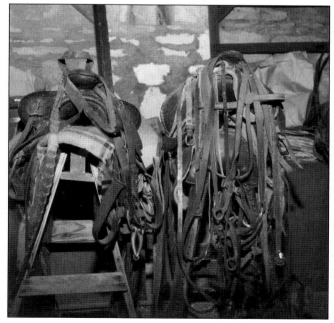

The Robertson Plantation has always been a working ranch. Sterling Robertson had 50 head of dairy cattle and sold milk products during World War II. Along with raising animals, he grew crops such as African sugarcane, cotton, wheat, rye, Indian corn, and oats. This photograph shows a couple of saddles in the storage room. (Robertson Plantation Archives.)

Lucille Armstrong Robertson, wife of Sterling Robertson Sr., showed her love for Salado by starting many of the events that are still celebrated. During the Texas Centennial celebration in 1936, she opened her home for what became the first of many public tours. She always took delight in sharing her home with visitors. In 1959, she and others founded the Central Texas Area Museum for the purpose of telling the history and development of the region. The museum continues to sponsor programs and events, including the annual Gathering of the Scottish Clans. In 1960, she initiated Salado's first Christmas Stroll, and in 1975, she conducted the first Annual Pilgrimage to Old Salado Homes. She also held Salado's first Texas Crafts Show in her yard. This show was in conjunction with a historical marker dedication ceremony at her home. (Robertson Plantation Archives.)

The front parlor is the most formal room of the house. This is where guests were received and afternoon tea was served. Originally, the walls were plastered and painted in a rose hue. In 1877, the colonel's oldest daughter, Luella, was married in this parlor, the first of many brides to be married in the home. The tall windows encouraged good airflow through the room. (Robertson Plantation Archives.)

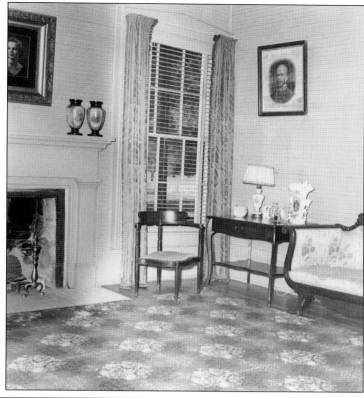

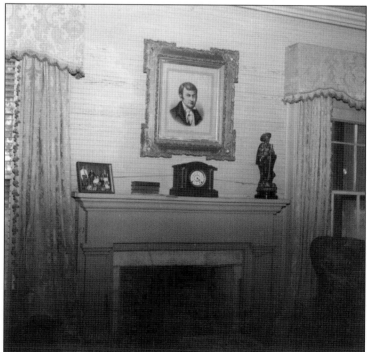

The photograph hanging above the fireplace in this back parlor is the colonel's uncle, James Robertson, founder of Nashville, Tennessee. This less formal room is where the family gathered to read. A ladies literary group, the Amasavourian (Love of Knowing) Society, was organized here in 1868. One of its first projects was to organize a circulating library, thought to be the first in the state begun and managed by women. (Robertson Plantation Archives.)

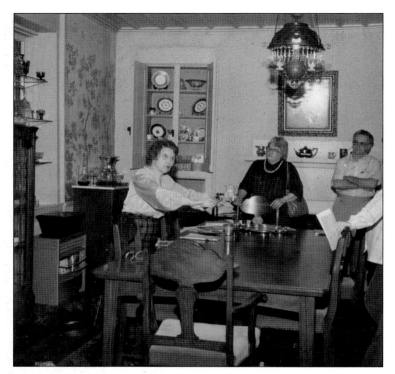

The dining room has several unique features. The fireplace mantel on the back wall is made of dressed limestone. The built-in cabinet on the back wall is where "sweets" were stored, and below it is a pass-through so food could be sent in from the kitchen. The table was often set with fine china and silver service. The serving spoons were made from coin silver by a Salado silversmith. (Robertson Plantation Archives.)

The pass-way room connects the main house to the rock house. This is where the family's water was obtained. In the early days, it was an outside space. Later, the hallway was enclosed. It included a working pump, making this the first room with indoor plumbing. Ann Robertson was a sculptress, and two of her bronzes are shown here. (Robertson Plantation Archives.)

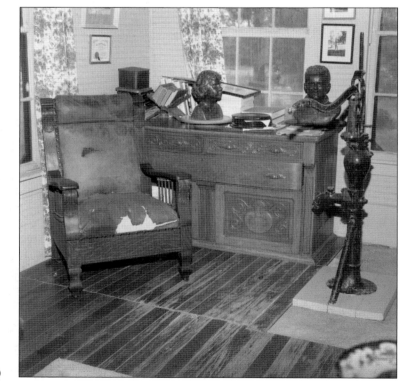

The storage room, just west of the kitchen, is a low-ceiling basement partially belowground. It has a stone floor and exposed cedar beams. A variety of items were kept in the storage room. Flatirons were used for the clothing and churns were used to make butter. The baskets were used for gathering eggs and crops from the peach and pecan orchards. (Robertson Plantation Archives.)

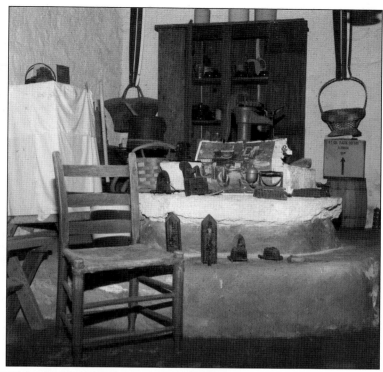

One of the busiest rooms in the house was the servants' kitchen. The house slaves cooked huge pots of homegrown food in the fireplace or on the stove in the kitchen adjoining the dining room. With the Robertsons' ever-growing family, houseguests, and slaves, it was not unusual for the house servants to prepare meals for 30 or 40 people three times a day. (Robertson Plantation Archives.)

The stranger's guest room was built to accommodate travelers and other strangers who might be passing through the area and need a place to stay. They could have a nice room to spend the night and leave the next morning without disturbing the family. In one of his journals, Robertson wrote that several travelers and strangers paid for their hospitality at the Robertson Home. (Robertson Plantation Archives.)

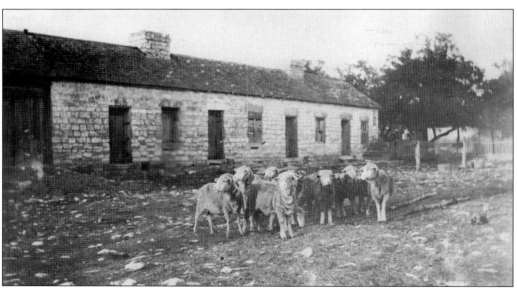

The slave quarters on the Robertson Plantation were built in 1861–1862. They are made of limestone and are immediately adjacent to the main house on the west. The building was divided into symmetrically composed bays. Each bay had a single wood door and a window. A double-sided fireplace for heating and cooking served each bay. These quarters were reserved for the house servants. They still stand at the plantation. (Tyler Fletcher.)

House servants cooked their food on this wood-burning stove or in the fireplace. The stove was also used to heat the room. The field hand houses were made of wood with stone foundations and were located on the edges of fields or pastures. The field hands also used wood-burning stoves for cooking and heating. (Robertson Plantation Archives.)

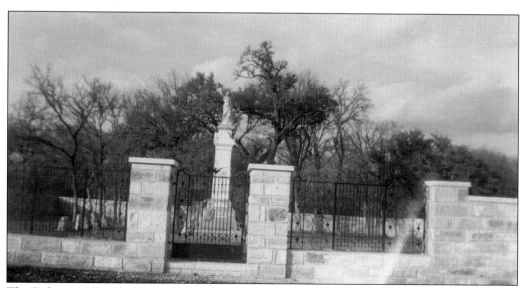

The Robertson Family Cemetery is located between the house and the Salado Creek. In 1858, Eliza Medora Susan Robertson, age six, was the first family member to be buried in the cemetery. Eliza was the daughter of Colonel Robertson and his first wife, Eliza Hamer Robertson. Originally, the cemetery was bordered by a fence of upright cedar posts. This 1957 photograph shows the stone wall that now encloses the cemetery. (Robertson Plantation Archives.)

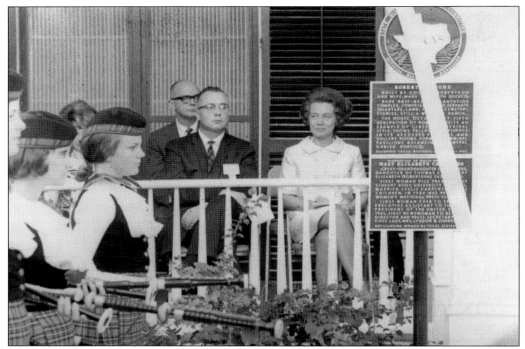

On August 25, 1967, two official Texas Historical Commission markers were dedicated at the Robertson Plantation. The first marker designated the Col. Sterling C. Robertson Plantation Complex as a Texas Historic Landmark. The second marker commemorated the public service of Mary Elizabeth "Liz" Carpenter, great-granddaughter of the builders of the Robertson Plantation and press secretary to Lady Bird Johnson. This photograph shows Nellie Connally, first lady of Texas, watching the ceremonies. (CTAM.)

Lady Bird Johnson, the nation's first lady, honored her press secretary, Liz Carpenter, with a personal appearance at the August 1967 historical marker dedication ceremonies. After the ceremony, Johnson visited with the guests. (C.B. and Mary Hodge.)

Three

A College is Founded and a Village Emerges

Col. E.S.C. Robertson was not only a wealthy landowner, businessman, statesman, and soldier, but also a philanthropist. The citizens of Salado and Bell County had often expressed the need for a high-quality school. Robertson was the moving spirit behind a joint effort to establish such a school.

In the fall of 1859, a tent meeting was attended by prominent men from all over the county at the Salado Springs on the Salado Creek. At the meeting, those present decided to raise the necessary funds for constructing a school by forming a joint stock company, to be named the Robertson Springs Joint Stock Company.

Colonel Robertson offered to donate 100 acres of land to the new school, to be called Salado College. Of this land, 10 acres were to be set aside for the construction of the college building and grounds. The remainder was to be surveyed, subdivided, and sold to finance the construction of the college. After Robertson's proposal, the name of the stock company was changed to the Salado College Joint Stock Company. Plans for the college were drafted two weeks later, and Hermon Aiken drew a map of the new town of Salado. The first lots were sold at public auction in December 1859.

On February 8, 1860, the legislature passed an act incorporating Salado College for a period of 20 years. Meanwhile, a temporary school building had been erected, and Salado College opened on February 20, 1860, in a small frame building. With the establishment of the school, more families began moving into the village and, very soon, new houses were under construction. Within a few months after the tent meeting, a village had emerged, and Salado had become a promising little settlement.

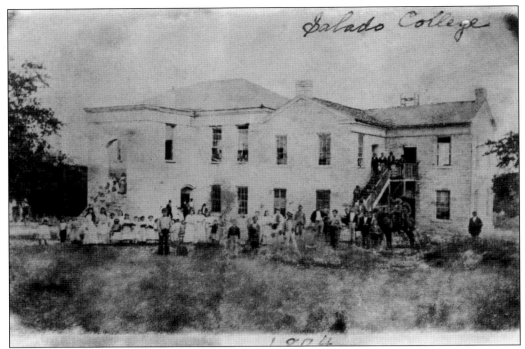

Salado College opened in 1860 with 75 students. It soon grew to 300, as many people moved to Salado to educate their children. The original building was the two-story ell structure shown on the right. The annex and south entrance on the west were added in 1869–1871. This 1874 photograph is considered to be the earliest known photograph of the college. (The Lena Armstrong Public Library, Belton, Texas.)

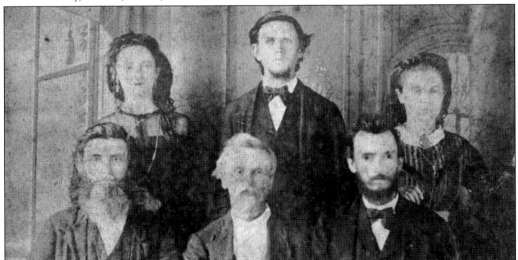

This is a photograph of the 1873–1874 faculty of Salado College. Shown here are, from left to right, (first row) Profs. W.T. Ethridge, Otto Fuchs, and James L. Smith; (second row) Sallie R. Young, Prof. Samuel G. Sanders, and Mittie Collins. Professor Smith served as principal of Salado College from 1863 to 1874 and again from 1879 to 1880. The college reached its highest enrollment, 307 students, during Smith's tenure. (SHS.)

26

Salado College was unusual at the time for being a coeducational institution. The college was founded in a time when higher education was for the wealthy and most colleges were for men only. Wealthy young women went to finishing schools. It took boldness and courage to build a coeducational college in a place where there was not yet an established town and certainly no outside help with financing. (Sophia Vickrey Ard.)

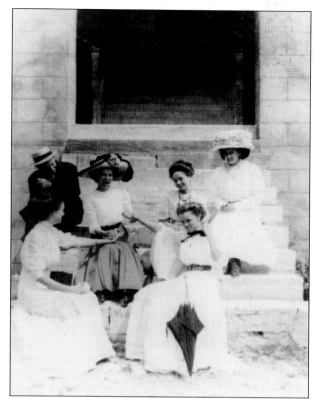

This is Salado College as it appeared in the early 1880s. The state charter for the school was granted in 1860 for a period of 20 years. During its tenure, hundreds of students had been educated at the school, known as "the Athens of the South." After the charter expired, the college operated until 1883, but did not issue diplomas. The school was a public school from 1884 to 1890. (Sophia Vickrey Ard.)

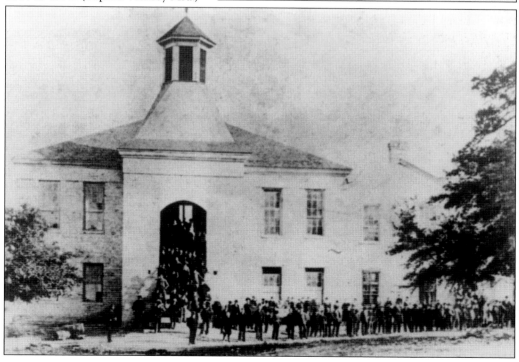

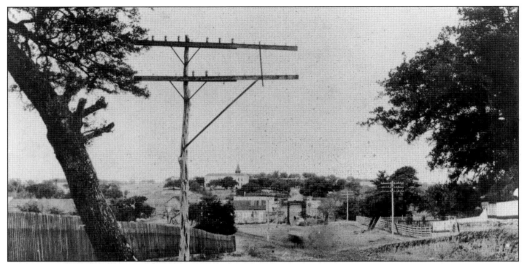

This photograph shows Salado as it was in the early 1900s. The main street was a rutted dirt road that led to the iron trestle bridge crossing the creek. In the distance is the college building with its backside facing the village. The photograph was taken from North Main Street, looking south. (C.B. and Mary Hodge.)

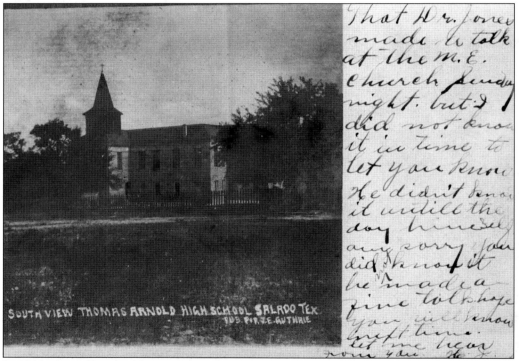

SOUTH VIEW THOMAS ARNOLD HIGH SCHOOL SALADO TEX

In 1890, the college building was leased to Dr. Samuel Jones for the purpose of establishing a private preparatory school, Thomas Arnold High School. This ushered in a new and significant era of educational opportunities for the old college building. With the leasing of the building, the public school had to seek other quarters. This July 17, 1908, postcard offers a south view of Thomas Arnold High School. (C.B. and Mary Hodge.)

This is a west view of Thomas Arnold High School. The horse-drawn buggy is coming down Main Street from the south. Even though the scene looks rough and rugged, within the walls of the high school, students were studying Greek and Latin. The girls were studying literature through the Elizabeth Barrett Browning Literary Society, and the boys were sharpening their debate skills through the Thomas Arnold Debating Society. (C.B. and Mary Hodge.)

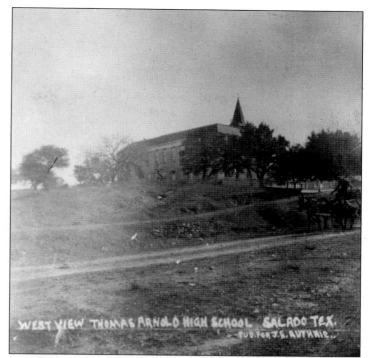

The 1917–1918 Salado College catalog gives a description of the college building after it had been rebuilt from the fires of 1901. It states that the classrooms, a laboratory, and a large, well-lit, and ventilated study hall with modern single seats are located on the lower floor. A library is at one end of the study hall. The upper floor has a large auditorium that seats 500. The music room is also on the upper floor. (SHS.)

This is the Thomas Arnold High School graduating class of 1898. Sophia Vickrey Ard donated this photograph to the Salado Historical Society in 1998. On the back of the photograph, Ard wrote a note explaining that her uncle Ralph Butler, second from the left in the first row, and her aunt Ethel Russell, just behind Uncle Ralph, were married in 1905. (Sophia Vickrey Ard.)

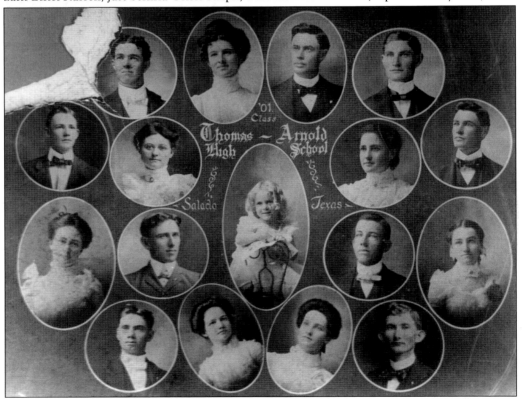

This is the Thomas Arnold High School graduating class of 1901. The child in the center of the photograph is thought to be the daughter of Professor Jones and his wife, Charlotte Hallaran Jones. (SHS.)

Louellen Eubanks, with diploma in hand, was a graduate of Thomas Arnold High School in 1901 or 1902. (SHS.)

Cleveland Edds was a 1906 graduate of Thomas Arnold High School. He was an active farmer and leader in Heidenheimer and, at one time, was on the county school board. (SHS.)

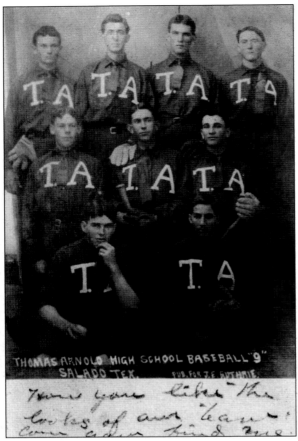

This postcard shows the Thomas Arnold High School baseball team of 1908. The postcard was sent to the Salado Historical Society 100 years later. The sender wrote that the card, postmarked January 22, 1908, had been mailed by his grandfather to his fiancé. The grandfather wrote, "How [*sic*] you like the looks of our team? Can you find me?" (SHS.)

During its incarnation as Thomas Arnold High School, the building suffered two fires. The first was in May 1901, and the second was in October 1901. The structure was rebuilt after each blaze, and the high school continued operations until 1913. A new Salado College, focused on teacher preparation, occupied the building from 1913 to 1918. When this school closed, the building was donated to the public school system. The public school occupied the building when the third fire occurred, in 1924. (Athena Vickrey Berry.)

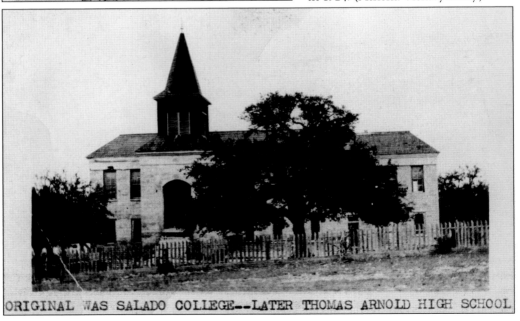

ORIGINAL WAS SALADO COLLEGE--LATER THOMAS ARNOLD HIGH SCHOOL

Within minutes of the pouring of kerosene and the striking of a match, fire had engulfed the beloved college building in May 1901. There was no fire department in Salado, so the citizens stood helpless as the blaze spread throughout the building. This photograph, taken within days of the first fire, shows the almost total destruction of Thomas Arnold High School. (Sophia Vickrey Ard.)

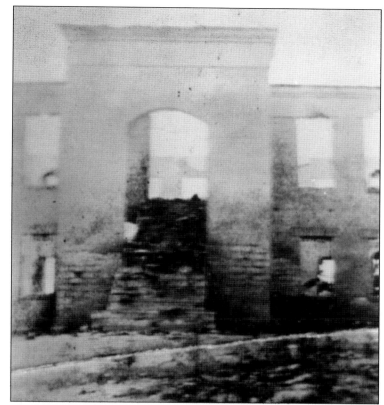

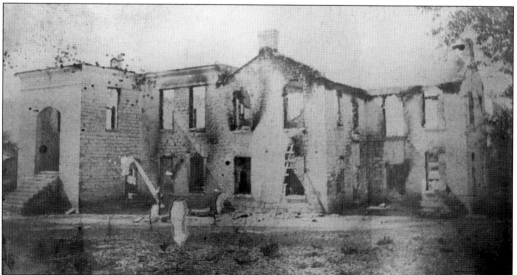

This photograph offers another view of the burned-out college building after the fire of May 1901. The building was not insured, but the community rallied around the school and provided financial assistance to rebuild. Just as the renovations were nearing completion, the school suffered a second fire. Investigations by authorities revealed that both fires were deliberately set. (Sophia Vickrey Ard.)

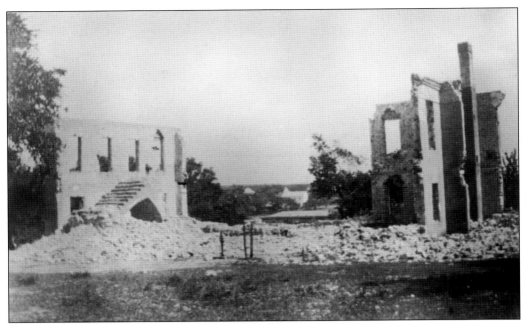

In June 1924, the college building was ravaged by a third and final fire. Once again, an investigation showed that the fire was purposely set. After this blaze, an inspection revealed that the remaining structure was beginning to crumble and was therefore declared unsafe. With this declaration, the era of Salado College, which had been the lifeblood of Salado for over six decades, came to a close. (Sophia Vickrey Ard.)

The ruins of the old college building have always attracted visitors. In January 1929, Lou Alice "Cissy" Aiken Durham visited the site. This photograph shows her sitting near the old water pump and water fountain. (SHS.)

This 1924 photograph captures the total destruction of the Salado College building and what had been Thomas Arnold High School and the free public school. Even though all three fires appeared to have been intentional, no arrests were ever made. Questions lingered about a possible connection between the fires of 1901 and the fire of 1924, 23 years later. (CTAM.)

The remains of the west wall of the old Salado College can be seen in this 1994 photograph. The rubble to the left is the steps that went up to the second floor of the building. This view looks to the west. Downtown Salado is to the viewer's right. (CTAM.)

This is a north (back) view of the Salado College building in 2013. The ruins have been stabilized, and the grounds are being developed into a family-friendly park. Salado College is listed in the National Register of Historic Places. The school's founders and former students have left an important legacy for the village of Salado, Texas. (SHS.)

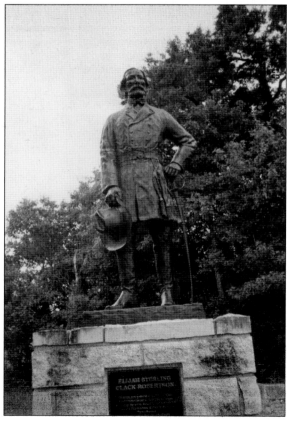

This life-sized statue of Col. Elijah Sterling Clack Robertson stands on top of College Hill, the site of Salado College. Behind him lie the ruins of the old college building. Looking relaxed and trim in his military uniform, Robertson seems pleased for being known as the founder of Salado and Salado College, and he seems to approve of his bird's-eye view of the main street of Salado. (Pat Barton.)

Four

EARLY BUSINESSES
OF SALADO

Some of the first Salado businesses were the mills along Salado Creek.

In 1849, Ira and Whitfield Chalk built the first gristmill on Salado Creek. This facility was later known as the Ferguson Mill. The W.A. Davis Mill was the first mill in the town limits of Salado. It was located in what is now Pace Park. Other mills soon followed, all contributing to the early business climate of Salado.

In its earliest days, Salado's Main Street was lined with businesses that met the needs of travelers, cowhands, and residents of an agricultural, ranching community. W.B. Armstrong operated the Stagecoach Inn in conjunction with a saddle and leather shop. The arrival of the weekly stagecoach, carrying mail, passengers, and baggage from Waco to Austin, always created excitement, and business for the inn.

Salado had a post office as early as 1852. In 1859, just before the Civil War, there were three small stores in Salado: Armstrong's leather shop; W.D. Copeland's hardware store; and Col. E.S.C. Robertson & Son's general merchandise store.

After the Civil War, Salado grew rapidly. According to the *Texas State Gazetteer and Business Directory* of 1884, Salado had seven churches, five schools, a steam gristmill, three cotton gins, and a number of stores. There were shipments of cotton, corn, wool, and hides. The stage ran daily to Belton for a fare of 75¢. The population of Salado was 700, and there was daily mail.

Several businesses have operated out of what is now The 1860 Shop, including a stagecoach line, livery stable, law office, drugstore, and grocery store. Travelers from Waco to San Antonio on the Chisholm Trail were frequent customers of the different businesses housed in the little rock building.

Most of Salado's early businesses have come and gone, but many of the buildings that housed those businesses still exist. The photographs that follow show the businesses that have occupied the buildings during more recent years.

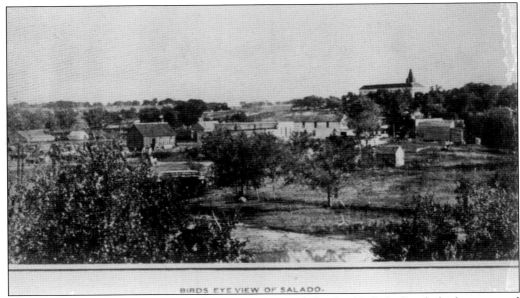

BIRDS EYE VIEW OF SALADO.

This bird's-eye view of Salado was taken from the north bank of Salado Creek, looking toward Salado College atop College Hill. Note the Salado Creek Bridge nestled among the trees on the left. This photograph appeared in the Thomas Arnold High School catalog of 1903. (Sophia Vickrey Ard.)

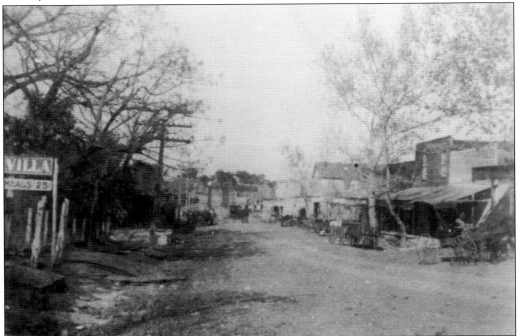

Salado's Main Street is seen here sometime before 1900. The Shady Villa Hotel, constructed in 1861–1862, offered meals for 25¢, and businesses lined both sides of the street. The street was pounded out of the dust by cattle and cowboys alike as they made their way toward the spring-fed waters of Salado Creek. (Sophia Vickrey Ard.)

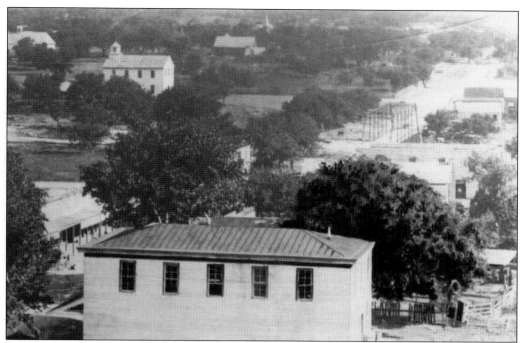

This is Main Street as it appeared in the early 1900s. The structure in the foreground is the old Grange building. The Shady Villa is hidden from view, but other businesses on the west side of the street are visible. The iron bridge and the Baptist and Methodist churches are in the background. The larger building to the far west supposedly was the public schoolhouse. (The Lena Armstrong Public Library, Belton, Texas.)

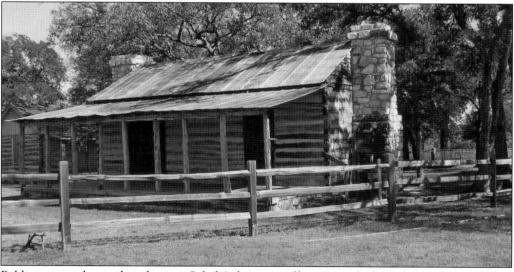

Public opinion has it that this was Salado's first post office. Records show that a post office was established in Salado on April 29, 1852, with Lewis A. Ogle appointed postmaster. This log cabin was restored after being found with a house built around it. In 1986, it was moved from its original location on Center Circle to its current location behind the Salado Civic Center at 601 North Main Street. (Ryan Hodge.)

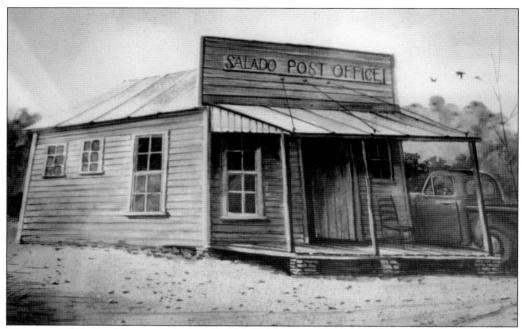

This post office building was located on the east side of Main Street. Mary E. Stevens was appointed acting postmaster on July 15, 1935. On December 24, 1935, Bertha M. Johnson was appointed to the position. She would serve for the next 32 years. This building was used until the early 1940s. (Ryan Hodge.)

In the early 1940s, Bertha M. Johnson sold the old post office building to Claude Hodge and built this one on the same spot. It was used until 1967. At the time this photograph was taken, the building was a shop operated by Paul and Virginia Kinnison. In the years to come, it would be a part of Salado Galleries, located at 409 South Main Street. (C.B. and Mary Hodge.)

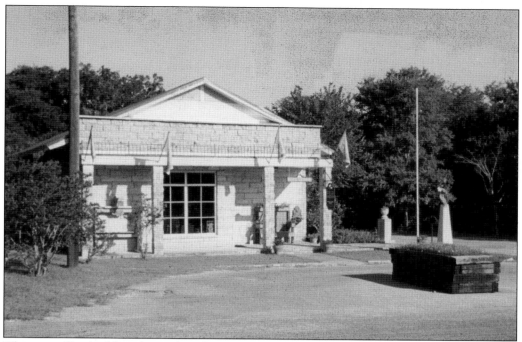

This post office building, located on the west side of Main Street, was dedicated on April 8, 1967. Bertha M. Johnson, who had retired the previous month after 32 years of service, presided at the dedication service. When Johnson retired, William R. "Bill" Bunker was sworn in as the new postmaster. The building was leased from the Sterling Robertson family. It is now Wells Gallery. (C.B. and Mary Hodge.)

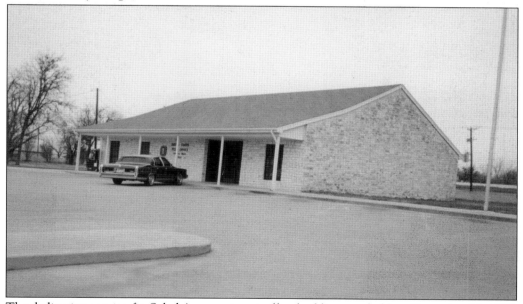

The dedication service for Salado's current post office building was held on December 16, 1988. Ida N.S. Pinkard was the postmaster. The building is located at 820 North Main Street. (C.B. and Mary Hodge.)

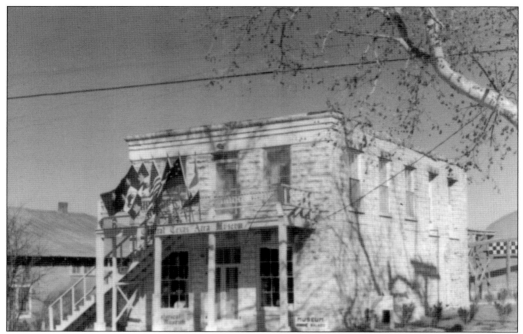

The Central Texas Area Museum stands on the corner of Main and College Hill Streets, across from the Stagecoach Inn Dining Room. Originally constructed between 1866 and 1876, it was a meetinghouse for the Salado Grange, the first in Texas. Later, it housed general stores, the telephone company, and even a shop that sold armadillo baskets. The museum received its charter in November 1958 and opened in August 1959. (CTAM.)

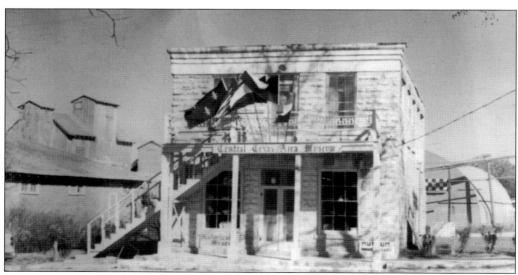

This photograph and the one above show the Central Texas Area Museum prior to the 1980–1981 addition to the south side of the building. The new addition housed a meeting room, library, and art gallery. The structure to the left of the museum is the Hodge Feed & Grain store. The structure in the back is the cotton warehouse that became Peddler's Alley. (CTAM.)

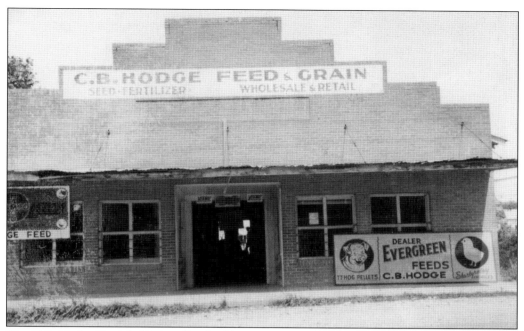

The C.B. Hodge Feed & Grain office building was erected in the 1920s by J.H. Norwood. A feed store was opened in 1946 to serve Salado's growing agricultural community. The store remained a feed store until 1957, when it was sold to Earl and Ruth Guest and Paul and Patsy Sanford. The building, still in use today as Sofi's, stands next to the Shady Villa shopping area. It formerly housed Salado Galleries. (C.B. and Mary Hodge.)

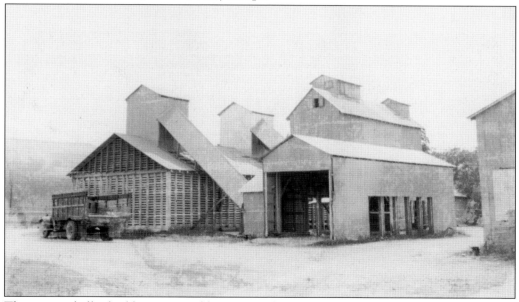

These corn-sheller buildings, erected by C.B. Hodge in the 1950s, were located south of Royal Street and behind the Central Texas Area Museum. They were sold to Earl and Ruth Guest and Paul and Patsy Sanford in 1957. The buildings were sold to Stagecoach Properties in the 1970s and moved to make room for parking. (C.B. and Mary Hodge.)

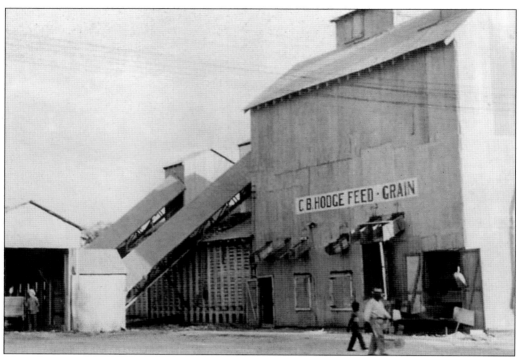

This photograph shows the C.B. Hodge Feed & Grain facilities in the 1950s. Corn was pulled by hand in the field and brought in to be shelled. The shelled corn was shipped to ports in Houston and Galveston. The shucks were baled for cattle feed, and the cob was ground for feed as well. During the harvest season, the shellers ran constantly until the harvest was finished. (C.B. and Mary Hodge.)

Claude Marion Hodge (left) and Glenn Allan Hodge stand in front of their father's feed and grain building. When the property was sold to Stagecoach Properties in the 1970s, the gin was removed, and the office was moved to family property west of Salado. (C.B. and Mary Hodge.)

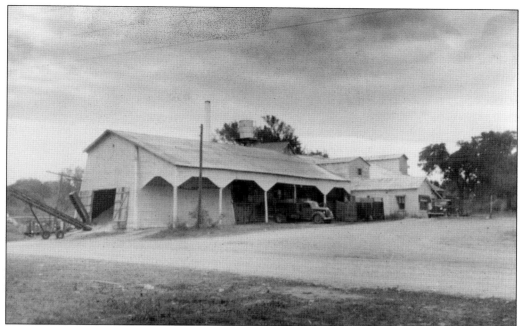

During the 1930s and 1940s, Salado was a thriving agricultural community. One of the most successful businesses in town was the Claude Hodge Cotton Gin. The cottonseed house was on the north end of the gin. The gin was located south of Royal Street and one block east of Main Street. (C.B. and Mary Hodge.)

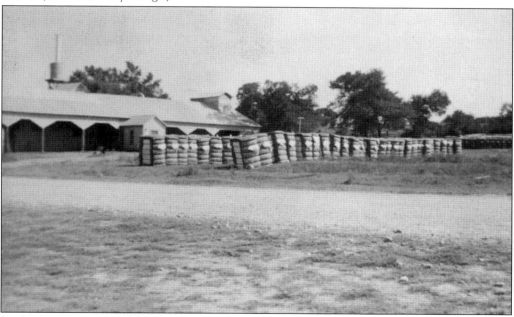

In the 1940s, a gin could process about four bales an hour, making square bales. Cotton was handpicked and brought to the gin in one-bale wagons. Farmers normally sold their cotton to Claude Hodge, the gin owner, who stored it in the warehouse, hoping the price would go up. (C.B. and Mary Hodge.)

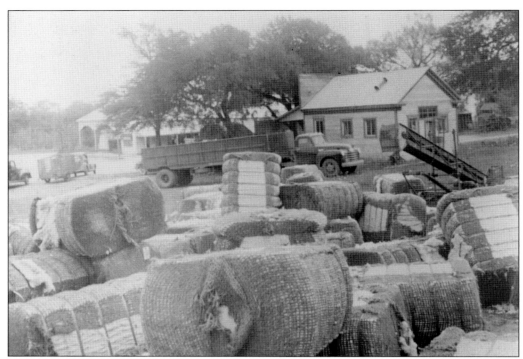

In 1945, Claude Hodge sold the cotton gin to Earl and Ruth Guest, who operated it until 1973, when they sold it to Stagecoach Properties. The small building in the background is the old post office. The gin was torn down in 1979, but the foundation remains at the original location. (Patsy Sanford.)

Remains of the foundation of the Hodge/Guest gin can still be seen on Royal Street near the former Dusty Rose building. This foundation is a symbol of days gone by, when Salado was a strong farming and ranching community. (C.B. and Mary Hodge.)

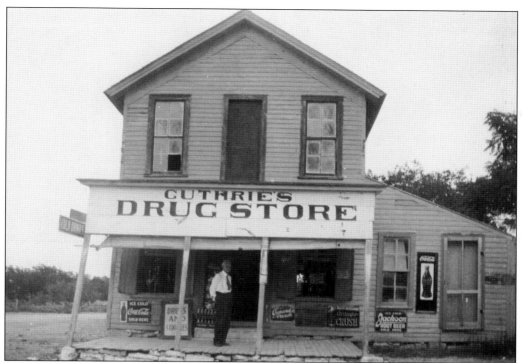

Guthrie's Drug Store was a two-story building near the southeast corner of Main and Royal Streets, near the current Shady Villa shopping area. The small building on the right housed a doctor's office. Early residents remembered going to see Dr. Guthrie, being diagnosed, and then watching as he mixed the liquid medicine. (Clyde and Wilma Capps.)

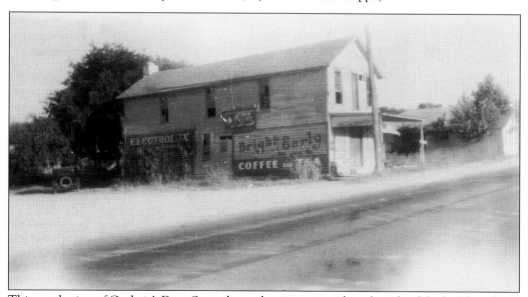

This north view of Guthrie's Drug Store shows the signs painted on the side of the building. Early residents say that Dr. Guthrie always had candy and soda water for his young, and young-at-heart, patients. (Prudie Capps.)

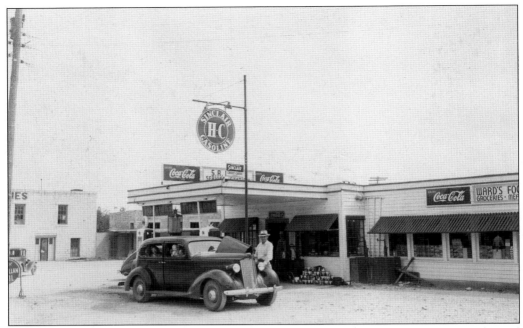

The Sinclair station and Ward Grocery were located on the southeast corner of Main and Royal Streets. It served the citizens of Salado and the surrounding area for 14 years, from 1947 to 1961. The station was built and initially operated by Seymour and Ora Lee Hodge, and the grocery store was operated by Tommy and Doris Ward. (C.B. and Mary Hodge.)

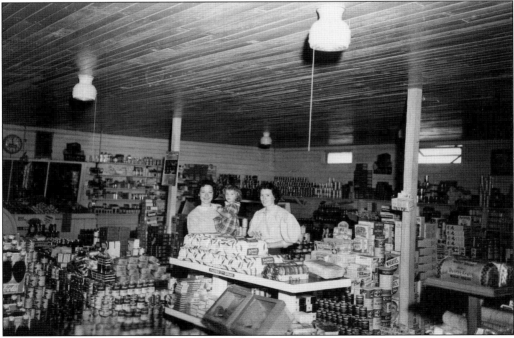

This interior photograph of Ward Grocery was taken in the late 1940s. Doris Ward (right) is ringing up a customer. The building is now a part of the Shady Villa shopping area. (Prudie Capps.)

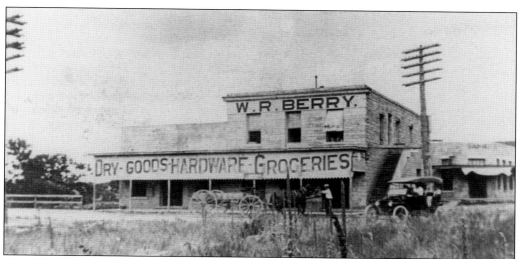

The W.R. Berry General Merchandise store stood on the northeast corner of Main and Royal Streets. It was a general-purpose store with creaky wooden floors and shelves filled with the necessities of a farm family of the early 1900s. In 1921, Salado Creek flooded the store with five feet of water, and all the merchandise was washed downstream. (SHS.)

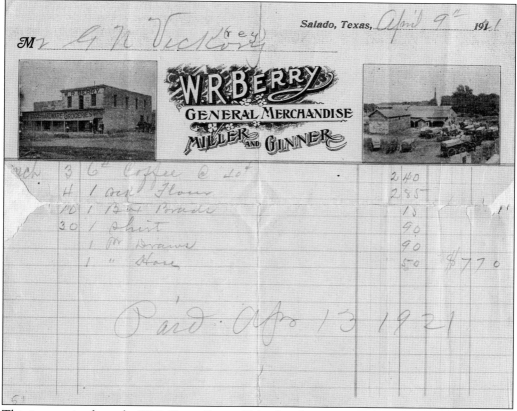

This is a receipt from the W.R. Berry General Merchandise store, made out to Mr. G.N. Vickrey on April 9, 1921. It is marked "Paid, April 13, 1921." (SHS.)

During the 1970s, the Cedar Hill Studio and Gallery was operated by Bill and Gretchen Jackson. The gallery stood next to the historic W.R. Berry store, situated on the south side of Salado Creek. (Egon Friedrich.)

The Shady Villa shopping area on Main Street was constructed in the early 1980s. It sits across from the present-day Stagecoach Inn, formerly the Shady Villa Hotel. When the hotel ceased using the Shady Villa name, it was transferred to the shopping area, allowing the historic name to remain in use. (Egon Friedrich.)

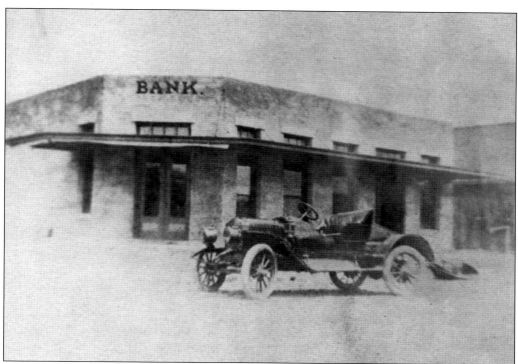

The First State Bank, Salado's first bank, was located near the northeast corner of Main and Royal Streets. It stood slightly behind the W.R. Berry Mercantile Store. In the days before drive-thru banking, customers had to park their cars and go into the bank to conduct their business. The bank operated from 1910 to 1919. (SHS.)

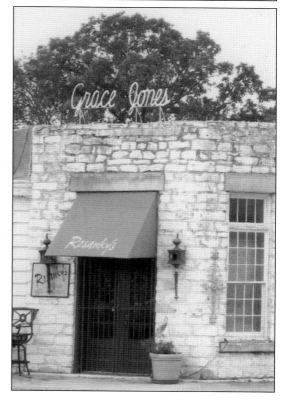

Grace Jones was a couture shop located at 1 Royal Street. In 1961, Grace and her husband, Lt. Col. Curran "Jack" Jones, remodeled the shell of the old bank building and opened a boutique filled with fashions from renowned designers from around the world. The couple was avid supporters of the Salado community. Every December, their gift to the ladies of Salado was a fashion show. (Maurice Carson.)

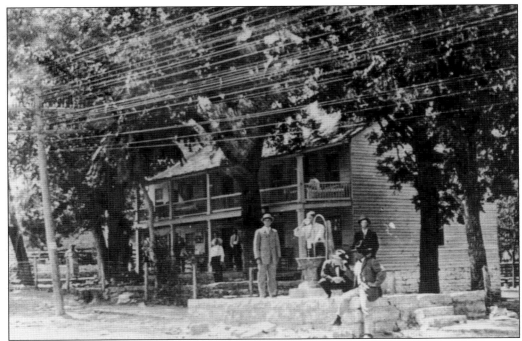

The Shady Villa Hotel, founded in the late 1850s, was on the west side of Main Street across from College Hill. It was built as a stagecoach relay station on the old Chisholm Trail and was a favorite stopping place for weary, hungry cowboys driving their cattle to Northern markets. The water well seen in this 1930s photograph was a favorite gathering place. The lines running overhead are telegraph wires. (Sophia Vickrey Ard.)

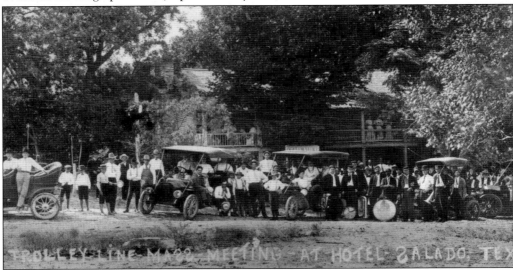

The Shady Villa Hotel was the scene for a mass meeting regarding a trolley line for Salado. In 1904, an electric railway was built to connect Belton and Temple. The power station was located at Midway, halfway between the two cities. The first trip of the new interurban line was made between Midway and Temple in November 1904. The railway operated until the early 1920s. There is no evidence that Salado was ever included on the route. (SHS.)

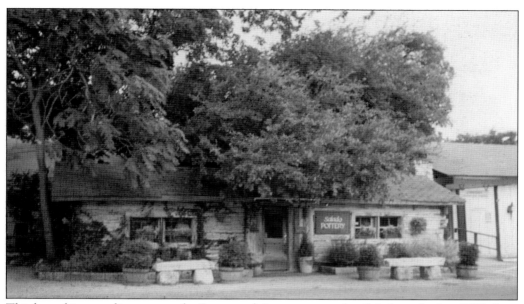

This log cabin, standing next to the Stagecoach Inn, was moved to Salado in the late 1930s from the Claude Hodge ranch. It had been the home of some of the earliest white settlers in the area. Since its arrival in Salado, the cabin has served as a small cafe, a pottery shop, and a home-decor store. (SHS.)

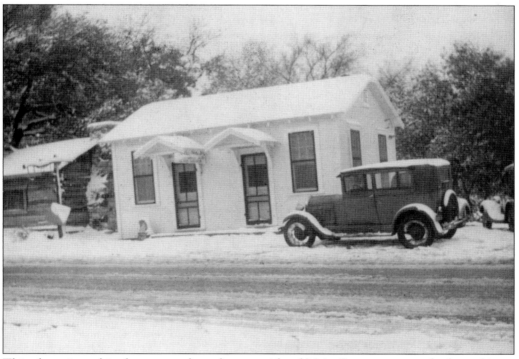

This charming white house stood on the west side of Main Street, next to the log cabin at Stagecoach Inn. This was the barbershop and beauty shop of Tiny and Preston Stanford. (C.B. and Mary Hodge.)

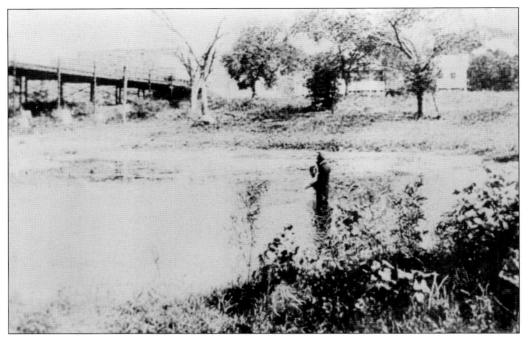

This photograph captures several images related to Salado, all revolving around Salado Creek. To the left is the second iron bridge. A baptismal service is taking place in the creek, and on the south side of the creek is Dr. Randolph's bathhouse, a clapboard-and-screened building. It was serviced by two artesian wells west of the bridge. The bathhouse and bridge were destroyed by the 1921 flood. (Sophia Vickrey Ard.)

Guest Service Station was located on the west side of Main Street, at the creek. The station stood on the spot formerly occupied by the bathhouse. It later became the Red & White Station. (C.B. and Mary Hodge.)

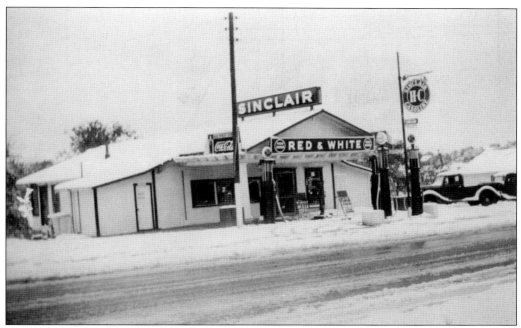

The Red & White Grocery and Station was located on the west side of Main Street, just south of Salado Creek. The store was owned by Seymour and Ora Lee Hodge. This building burned down in the fires of the late 1930s. (C.B. and Mary Hodge.)

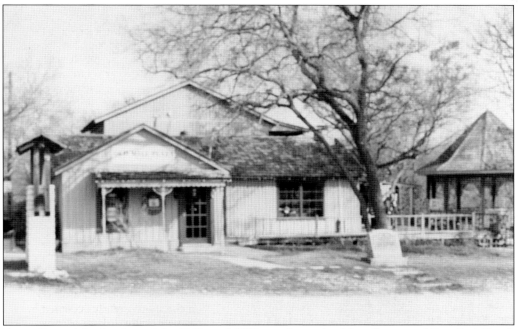

Aaron Rosser's barbershop of the 1940s and 1950s was located at Main Street and Pace Park Road, on the site of the old Davis Mill. (C.B. and Mary Hodge.)

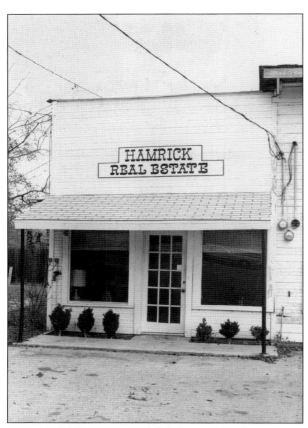

The Hamrick Real Estate office was located on the north side of Salado Creek, in the shopping area across the street from the Baptist church. It was attached to the north end of what is now the Strawberry Patch. (Egon Friedrich.)

The *Salado Village Voice* newspaper occupied this little building in 1986. It was located on the corner of North Main and Rock Creek Streets. Currently, the *Salado Village Voice*, published weekly, is located in the Salado Plaza shopping center. In April 2013, the current owners of the newspaper marked their 25th anniversary as owners and publishers of the paper and its quarterly magazine, *Salado: A Jewel in the Crown of Texas.* (SHS.)

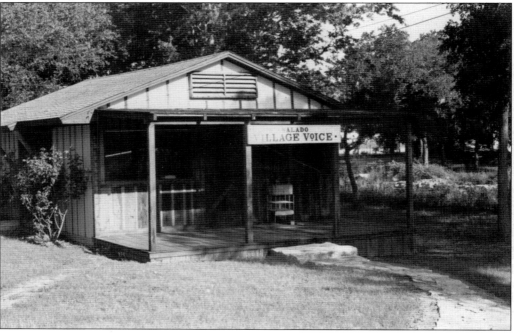

The Old Saloon, now known as The 1860 Shop, was the site of a "sit-in" protesting the opening of what was to be the first saloon in Salado. According to folklore, a man rolled into Salado with the intent of opening a tavern in the building. However, no male customer dared pass through the row of protesting women sitting on the front porch in their rocking chairs, knitting and reading the Bible. The saloon closed the next day. (Egon Friedrich.)

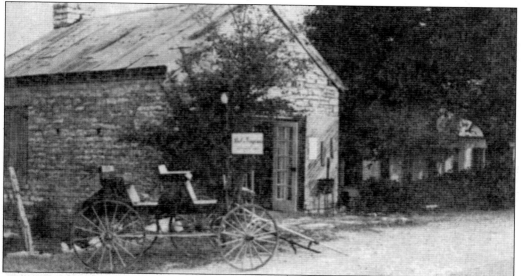

In 1963, Paul & Virginia Antiques and Art shop opened in the little rock structure formerly known as the old saloon building. The shop specialized in primitive antiques of Texas's days. Virginia Kinnison was cochairman for the first Salado Art Fair, held in 1967, which drew several thousand people to Salado. The store, currently known as The 1860 Shop, continues to sell one-of-a kind handmade items. (C.B. and Mary Hodge.)

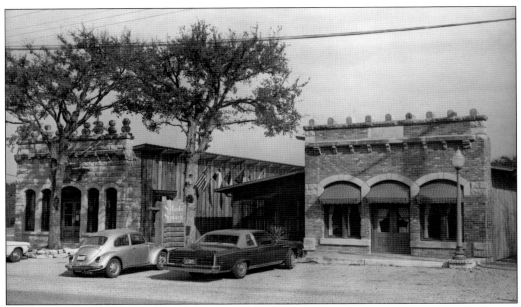

The Salado Square shopping area is on Main Street, just north of Pace Park Road. Salado Square was built by local artisans who incorporated facades from the West Texas town of Santa Anna. Today, it houses several of Salado's finest shops and a luncheon cafe. (Egon Friedrich.)

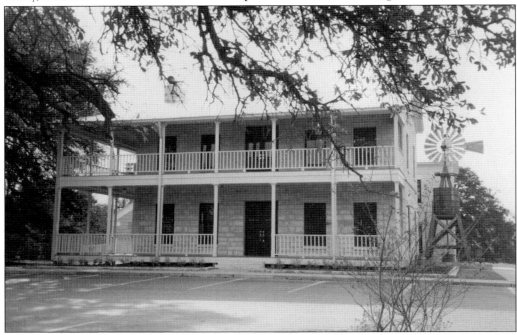

The Old Scotts Hotel, now known as the Veranda, was moved to Salado from nearby Lampasas. In order to maintain the integrity of the 1855 building, it was taken apart piece by piece, with each piece carefully labeled and numbered. In the 1980s, the building was reassembled at its current location on Main Street next to the historic Tyler House. The beautiful old building, once headed for demolition, now houses professional offices. (LaVerne Gore.)

Five

SALADO CREEK'S PEACEFUL NATURE AND ITS FRISKY NATURE

Salado Creek, a natural beauty of the village, is fed by large springs that, at one time, were known to shoot four feet into the air. These ever-flowing springs emerge from the Balcones Fault, a geologic line running from north to south through Central and South Texas. From the 1860s to the 1880s, the spring-fed waters powered nine mills along eight miles of the creek.

The name *Salado*, given to both the town and the creek, means "salty" in Spanish, even though the water is fresh. There is evidence that the creek, which flows through town year-round, was the site of a camping ground for the Indians. In 1838, a military road extended across the Republic of Texas and crossed Salado Creek at the place where Main Street does today. This road later became an overland stage route and was used as a branch of the Chisholm Trail. From the 1860s to 1885, thousands of cattle were driven along this route to Northern railheads.

Even though the Indians have left the area and the cattle drives no longer pass through, Salado Creek has not lost its appeal. It still attracts visitors. A frequently visited spot is the pool at which stands the bronze sculpture of Sirena. This half-mermaid, half-maiden statue has been a treat for visitors and residents alike.

Usually, the creek is peaceful and calm; however, after heavy rainfalls, it can be frisky and destructive. Floods have destroyed three bridges across the creek. It seems that each flood is worse than the previous one, but old-timers say that none compare to the great flood of 1921, when homes, barns, crops in the field, and livestock were washed away and lives were lost.

Even with its occasional destructive nature, Salado Creek remains a favorite gathering place. Families gather for reunions and picnics, and its swimming holes still invite children. Occasionally, when driving by the creek on a Sunday afternoon, one can witness a baptismal service taking place among the water-cress growing around the springs.

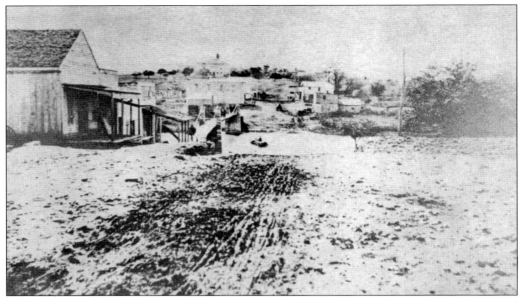

This 1884 view of downtown Salado offers a glimpse of the cable suspension bridge spanning Salado Creek. This bridge, engineered by the town fathers, was in use between the 1870s and 1913. Prior to the construction of the bridge, pedestrians crossed the creek by stepping from rock to rock or walking on logs laid across the wider places. All too frequently, pedestrians tumbled into the water. (SHS.)

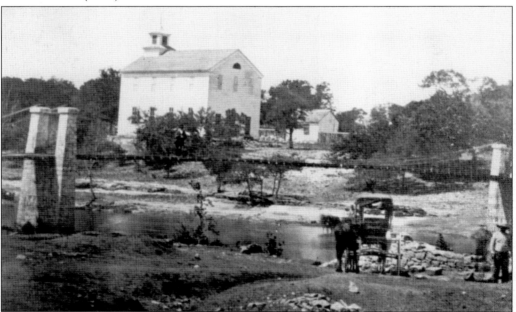

This 1870s cable suspension walking bridge crossing Salado Creek is reported to be the first of its kind in the Southwest. Bonds were issued to cover the cost of the construction, and recently freed slaves volunteered their labor. The old Salado Baptist Church building is clearly visible in the background. This photograph was taken between 1870 and 1892. (The Lena Armstrong Public Library, Belton, Texas.)

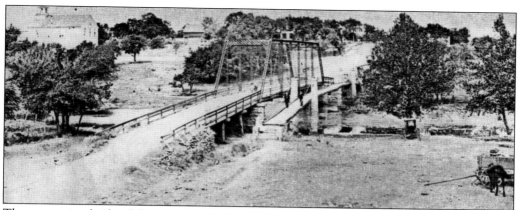

The suspension bridge did not accommodate wagon traffic, so, in 1892, Bell County contracted with the King Bridge Company to build this iron-top bridge over Salado Creek at a cost of $3,500. The bridge sat a few yards west of the suspension bridge. This is a rare photograph showing both the suspension bridge and the wagon bridge. (SHS.)

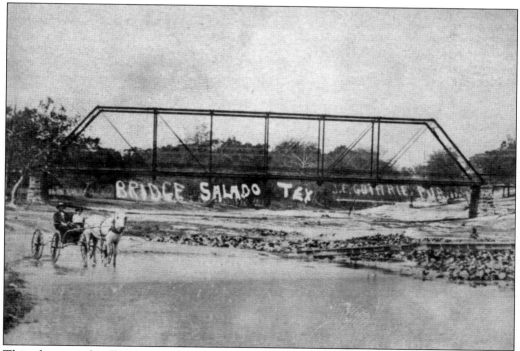

This photograph offers another view of the first iron bridge across Salado Creek. Both the suspension bridge and the wagon bridge served Salado until 1913, when a thunderstorm sent a terrific flood down Salado Creek, washing both bridges away. William Henry Truelove is in the buggy. (SHS.)

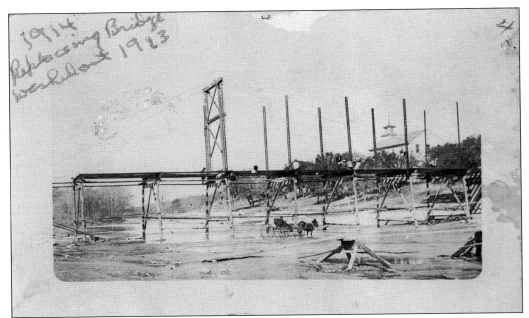

This is a view of the second iron-top wagon bridge under construction. The old two-story Baptist church building is in the background. The bridge, built in 1914, replaced the bridge lost in 1913. This bridge was destroyed in the great flood of September 9 and 10, 1921. (Byron Bunker.)

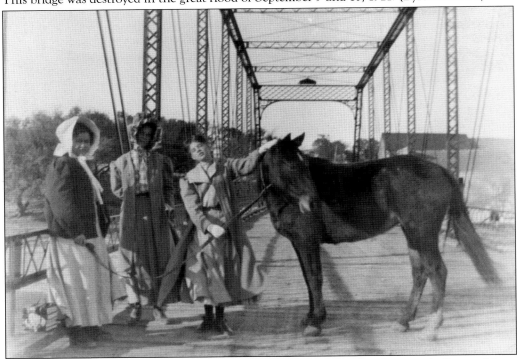

Three girls and a horse pose on the 1914 wagon bridge for a keepsake photograph. Pictured from left to right are Lucy Berry, Sophia Vickrey, and Ruth Miller. The horse's name is not known. (Sophia Vickrey Ard.)

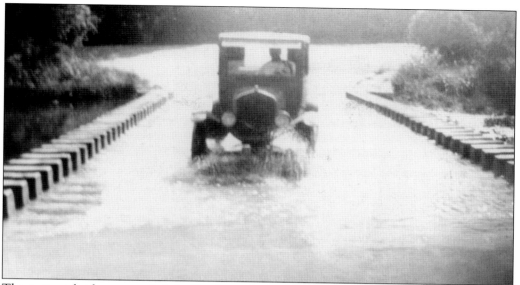

The current bridge across Salado Creek was built in 1922 by the state highway department. The previous bridges had not been anchored to the rock creek bottom. When this bridge was constructed, reinforced steel was anchored three to five feet into the creek bottom. A walkway was added to the east side of the bridge in the early 1940s. The bridge and the walkway have survived several floods during their lifetimes. (Sophia Vickrey Ard.)

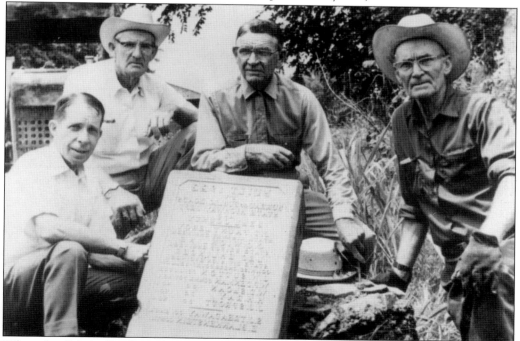

When the Salado Creek Bridge was constructed in 1922, a cornerstone marker was placed at the southeast end of the bridge. It is surmised that the marker was knocked off the bridge by an automobile accident and lay unnoticed for years. In 1957, it was found half-buried in mud by, pictured from left to right, Paul Kinnison, Earl Guest, Roland Bishop, and Byron Bunker. (SHS.)

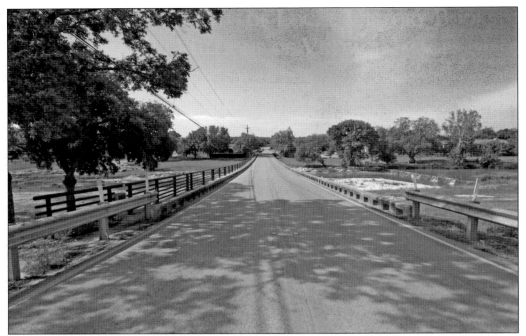

This photograph shows the 1922 bridge as it appears today. The cornerstone marker, found in 1957, now sits at the southwest corner of the bridge. The Stagecoach Inn Conference Hall can be seen to the right of the bridge. (Ryan Hodge.)

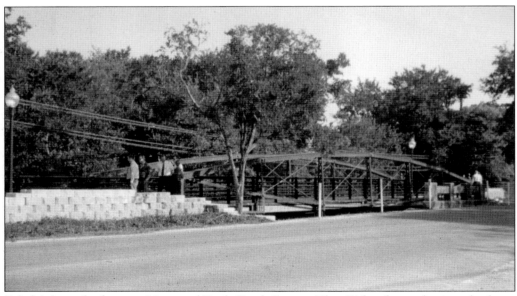

Salado's latest bridge is at Main and Rock Creek Streets. This 87-foot lenticular truss bridge is one of eight such bridges surviving in Texas. This bridge, known as Dodd's Creek Bridge, was moved to Salado in 1997. This historical bridge serves as a footbridge over the Campbell Branch waterway. (C.B. and Mary Hodge.)

Published for Dr. Guthrie in 1908, this postcard photograph is thought to be one of the earliest images of Salado Creek. This view looks east from the Salado Creek Bridge. The tree-shaded areas along the creek were the sites of family gatherings, summertime campouts, and protracted (revival) meetings. When a protracted meeting was announced, families were encouraged to bring provisions for themselves and their horses. (C.B. and Mary Hodge.)

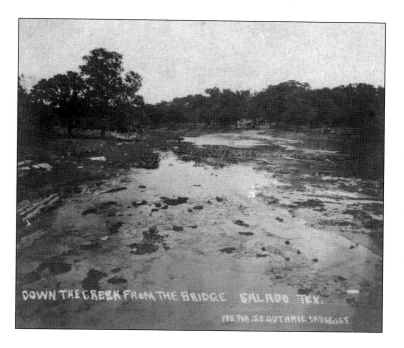

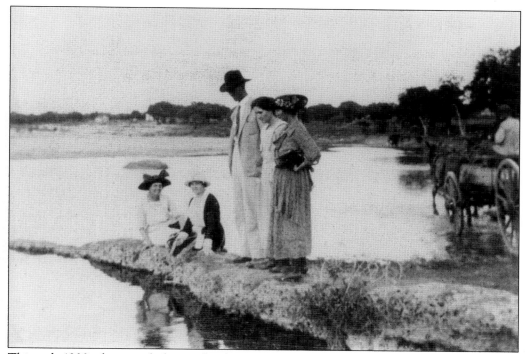

This early 1900s photograph shows a family enjoying an outing on the banks of Salado Creek. The view is from the Salado Creek Bridge, looking east. During the summer, many families camped out at the creek all season long. The W.R. Berry store advertised bathing suits and tents for rent or sale in the Salado College Catalog of 1917–1918. (Susie Cabiness.)

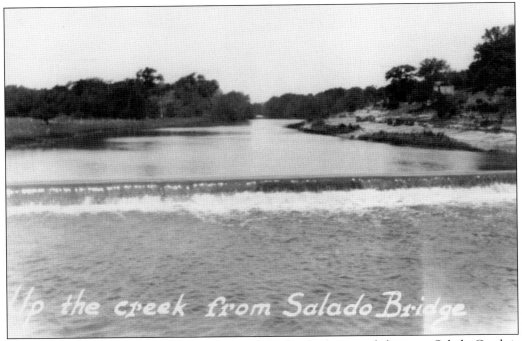

Up the creek from Salado Bridge

This photograph, taken from the Salado Creek Bridge, looks toward the west. Salado Creek is seen prior to the construction of Interstate 35, when US Highway 81 was the main street through Salado. (C.B. and Mary Hodge.)

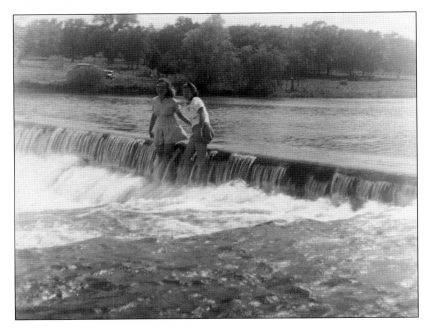

Salado Creek rushing over the dam provides a refreshing break on a hot summer day for two teenage girls. This photograph was taken in the 1940s, before the Stagecoach Inn Motel was built. The motel stands on the south side of the creek. (C.B. and Mary Hodge.)

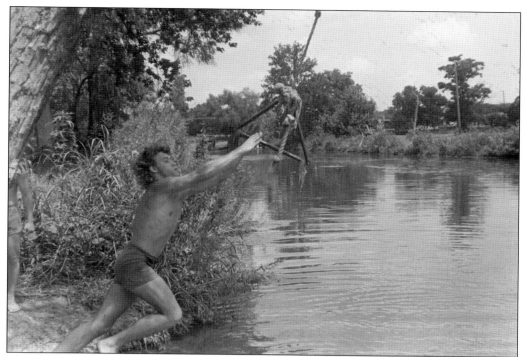

There were several swimming holes along the creek, including, west of Main Street, the Calico Hole and the Robertson Hole. On the east side of Main Street were the Big Spring, the Blue Hole, and the Long Hole. The Blue Hole was cold, deep, and the only place to catch blue catfish. This photograph shows a young Tarzan about to swing into his favorite swimming hole. (C.B. and Mary Hodge.)

This 1970s view of Salado Creek shows the Interstate 35 bridges that cross over the creek. Both the tall bridge and the lower bridge were completed in 1957. The lower bridge was removed in the spring of 2013 due to the widening of Interstate 35 through Salado. The low-water dam was built in the early 1930s. (Rita Zbranek.)

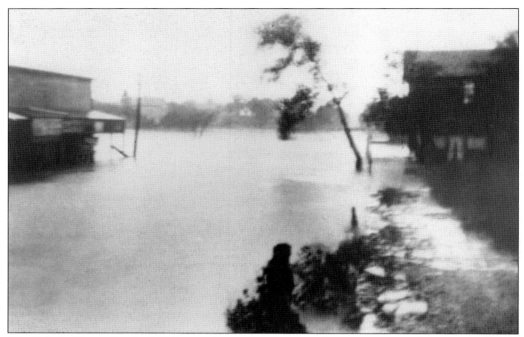

The Salado Creek flood of 1921 remains one of the most destructive natural disasters to strike the Village of Salado. Records show that it rained nonstop for two days. The waters of Salado Creek rose 25 to 50 feet, swallowing everything and everyone in its path. This photograph was taken from the east side of Main Street, looking north. The Baptist church and the Tyler house are visible in the background. (SHS.)

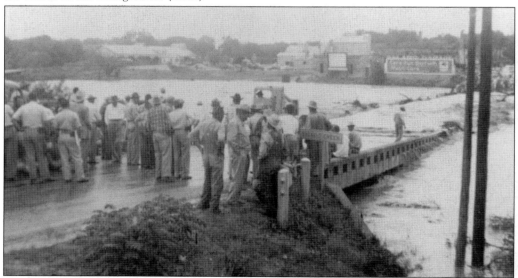

The Salado Creek flood of the 1950s was destructive, but the Salado Creek Bridge, built in 1922, withstood the rushing water and debris that pounded against it. The bridge still stands today. The structures in the background are the cotton gin (far left), the feed and grain facilities, a giant outdoor movie screen, and a sign for Salado Garage painted on the roof of the building. This view was taken from the north, looking south. (Jessie Foster.)

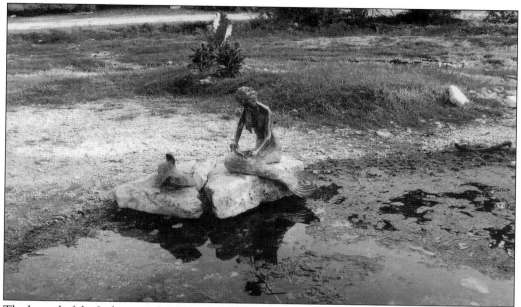

The legend of the Indian maiden Sirena and the catfish inspired local sculptor Troy Kelley to create this bronze sculpture. Placed in Salado Creek in January 1986, it shows Sirena trying to remove a fishhook from her fin. The low-water level in the creek during the drought of July 2009, when this photograph was taken, offers a good view of both Sirena and the catfish. (Charlene Carson.)

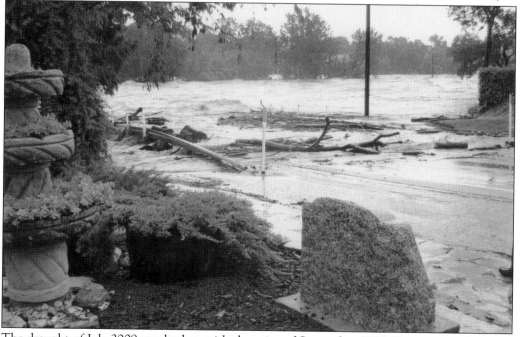

The drought of July 2009 was broken with the rains of September 2009. Once again, the Main Street Bridge was completely covered with rushing water. This view is from the northeast side of the creek, looking toward the west. The marker in the foreground is the Davis Mill marker. (C.B. and Mary Hodge.)

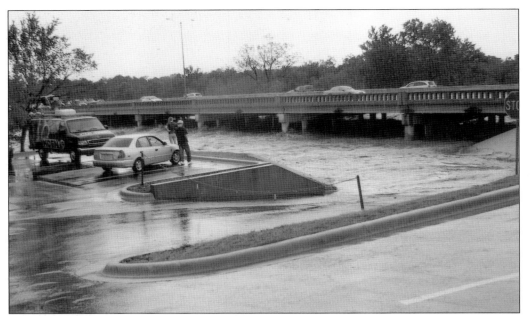

The I-35 Bridge over Salado Creek is seen here during the September 2009 flood. Note that the frontage road is completely underwater. This view is from the parking lot of the Baptist church, looking west. (C.B. and Mary Hodge.)

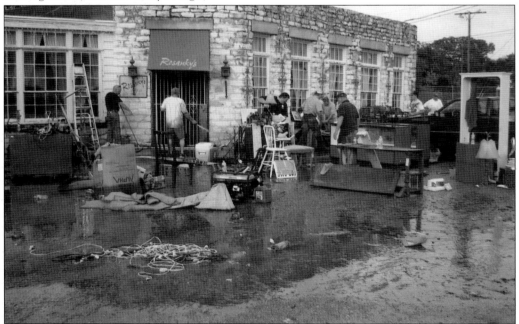

The W.R. Berry building, which houses Rosanky's, one of Salado's fashionable home-decor shops, suffered damage from rising water during the flood of 2010. Many people compared the flood of 2010 to the flood of 1921 in terms of property damage and loss. This photograph shows village residents working together to clean and restore homes and businesses after the waters had subsided. (C.B. and Mary Hodge.)

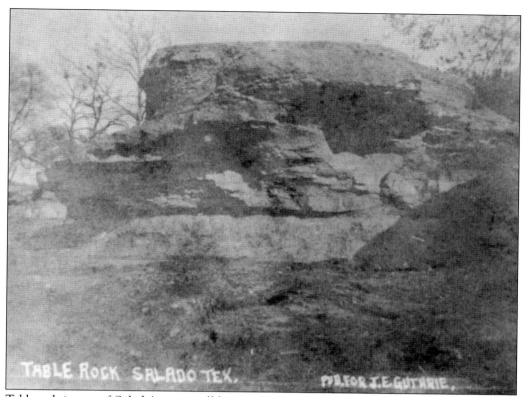

Tablerock is one of Salado's most well-known landmarks. This early-1900s photograph shows this natural phenomenon in its original state as a flat-topped table. It was a favorite spot for moonlight picnics for Salado College students. The initials carved in the rock face by students are still visible. (Sophia Vickrey Ard.)

This 1906 photograph of Tablerock shows a crack in the stone, caused by the undercutting of the 1900 floodwaters. The undercutting from the flood of 1921 finally caused the huge rock to give way, leaving half of it tilted, as it still is today. The child in the bonnet is Athena Vickrey Berry. (Sophia Vickrey Ard.)

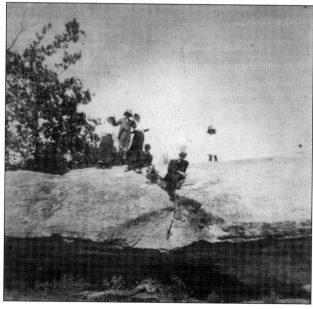

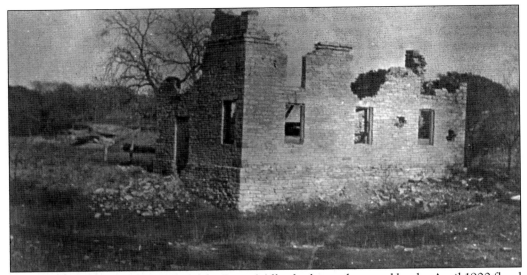

This photograph shows the ruins of the Davis Mill, which was destroyed by the April 1900 flood and never rebuilt. The Davis Mill started as a wool-carding mill, but it was later converted to a flour mill. A note by Sophia Vickrey Ard on the back of the original photograph states, "This picture has been published as part of ruins of Salado College. . . . NOT. . . It is the ruins of the old Davis Mill." (Sophia Vickrey Ard.)

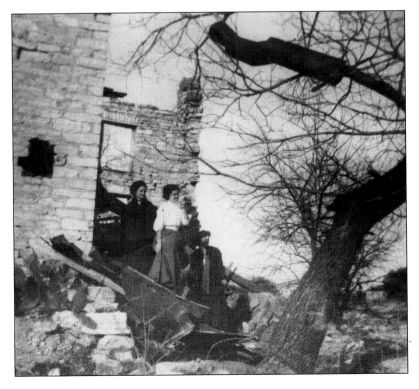

Thomas Arnold High School girls stand on the steps of the ruins of the Davis Mill. Twelve Oaks, the home of Dr. B.D. McKie, can be seen at lower right. A note by Sophia Vickrey Ard on the back of the original photograph states that she thinks the girls are a Robertson and a Goode girl, and perhaps a Davis girl. (Sophia Vickrey Ard.)

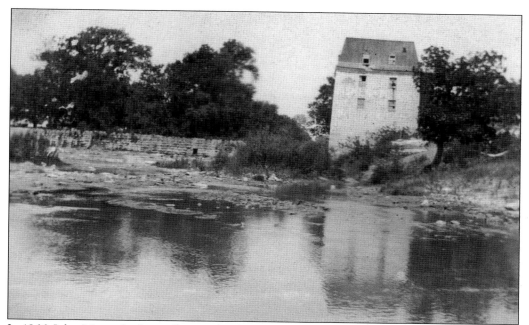

In 1866, John Meyers built a mill several miles down Salado Creek, at what is now the crossing of Belton and Holland Roads. Meyers sold the mill to D.C. Summers in 1879, and it became known as Summers Mill. In a short time, a community, also known as Summers Mill (Sommer's Mill), grew up around the mill. J.R. Holland bought the mill in 1888. In 1890, he replaced the original wood dam with rock and rebuilt the structures after the flood of 1921. The mill was operated by Holland's son-in-law J.M. Phillips and his son Leland Phillips until 1958, when the son closed it down. These two photographs show the mill as it appeared in 1890. (Both, Tyler Fletcher.)

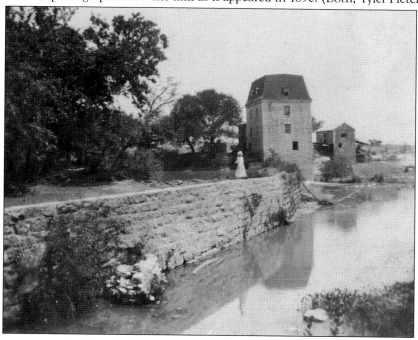

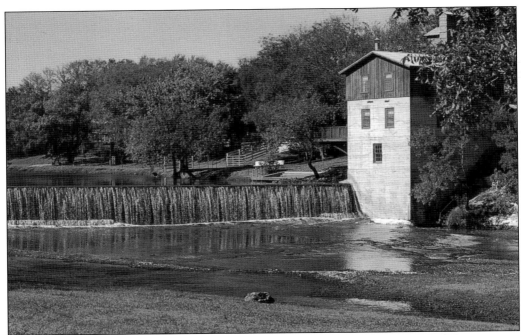

This is Summers Mill as it appears today. On April 21, 1968, a Texas Historical Commission marker was dedicated at the site. At that time, it was the only operable gristmill in Texas. The mill is now part of Summers Mill Farm and is a popular retreat and conference center. (SHS.)

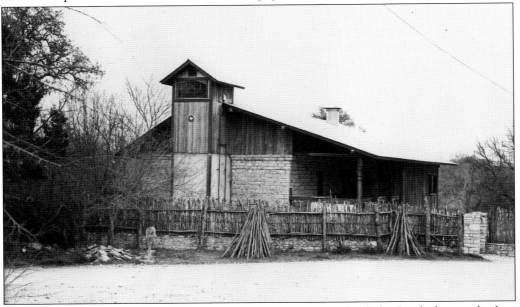

Stinnett Mill was one of eight mills built along the banks of Salado Creek during the late 1800s. It has been noted that Stinnett Mill, the only surviving mill, owes its survival to the fact that it was not built directly on the creek banks, as the others were. It was erected on a slightly elevated site, and a dam built upstream diverted water into the mill to power the grindstone. (Egon Friedrich.)

Six

HISTORIC FAMILY HOMES
AND
OTHER HISTORIC SITES

In 1847, Salado's first white settler, Archibald Willingham, a 63-year-old veteran of the War of 1812, and his two sons, Jack and Wilson, built the first home in Salado. It was a typical frontier, double log cabin with a dog run between. It was erected near Salado Creek.

A few years later, Col. E.S.C. Robertson bought the Willingham property. He moved to the cabin, leaving his family in Austin, while he began construction of their plantation home. Willingham, meanwhile, purchased land and made a homestead farther up Salado Creek, near Willingham Spring.

The Willingham cabin no longer exists, but there are historic cabins in Salado as well as several historic homes and sites. Most are marked with a Texas Historical Commission Marker, and many are listed in the National Register of Historic Places.

The Texas Historical Commission, formerly known as the Texas Historical Survey Committee, was organized in 1953. Its purpose is to identify important historic sites and subjects across the state so that people may be educated regarding the historical nature of the site or subject. The state sets the standards and guidelines for securing a marker.

The National Register of Historic Places (NRHP) is the federal government's official list of districts, sites, buildings, and objects deemed worthy of preservation. At this time, Salado has 17 properties in the National Register of Historic Places. Most were listed in 1983. One was listed in 1991 and another in 1995. The homes range in style and size, from simple ranch-style homes to the stately 22-room Robertson Plantation.

The early families of Salado were educated and refined. They built homes of quality that reflected their station in life. Salado is a town with an unusually large proportion of surviving historic homes and properties. It is rare to find so many well-preserved buildings in such close proximity to each other.

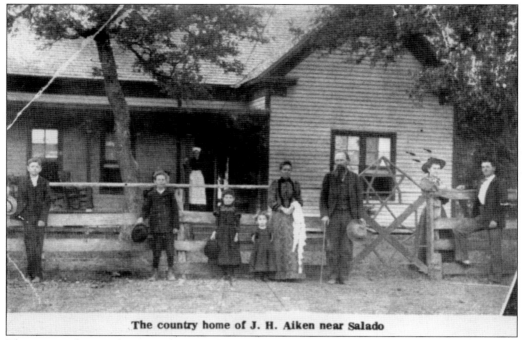

The country home of J. H. Aiken near Salado

The country home of James Hermon Aiken was located east of Salado. James Aiken was the son of Col. Hermon Aiken, who surveyed the initial lots for Salado. Shown here are, from left to right, Jim Aiken, Carl H. Aiken, Josephine Aiken, Alimae Aiken, Louisa "Lou" Damron Aiken, Hermon Aiken, Myrtle Aiken Caskey, and Elmer Aiken. (SHS.)

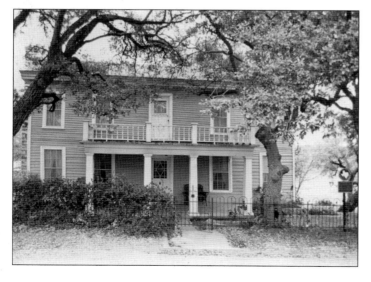

James B. Anderson and his wife, Elizabeth, built their 1860 home near an old Indian campground. The framed house, located at 35 South Main Street, was made of cedar and cypress and was built in several stages. The window glass is hand-blown. Anderson was a Salado College trustee and one of the founders and charter elders of the local Church of Christ. The house has a Texas Historical Commission marker and is listed in the NRHP. (Egon Friedrich.)

The Armstrong-Adams House is a one-story Greek Revival structure. The home was built between 1868 and 1872 by Dr. David H. Armstrong. For many years, it was the home of Dr. D.G. Adams and his family. Another former owner was Dr. James E. Guthrie, a practicing Salado physician. The home currently serves as an office and residence to one of Salado's dentists, Dr. Douglas Barton Willingham. (Doug Spiller Photography of Salado.)

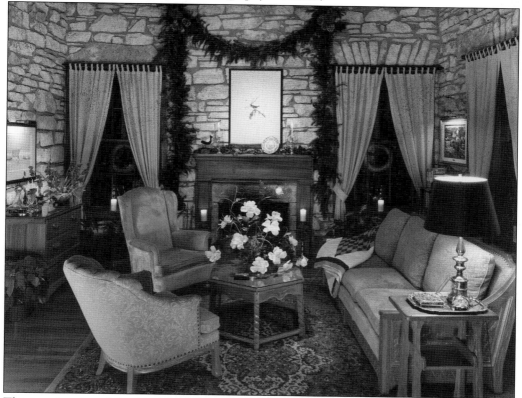

This interior view of the Armstrong-Adams House features the lovely, well-appointed living room, beautifully decorated for the Christmas season. The house, located at 2 North Main Street, has a Texas Historical Commission marker and is listed in the NRHP. (Ron Dorsey of Austin.)

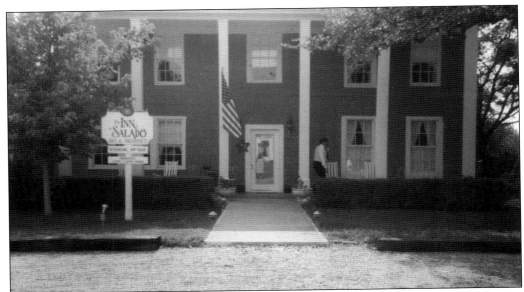

The Inn at Salado is located on North Main Street in the heart of Salado. Previously, the inn was the private home of Col. Nimrod and Mary Norton, and then it was the home of John and Kate Orgain. Currently, it is one of Salado's signature bed-and-breakfasts and is host to many weddings and receptions. The inn has a Texas Historical Commission marker and is registered in the NRHP. (SHS.)

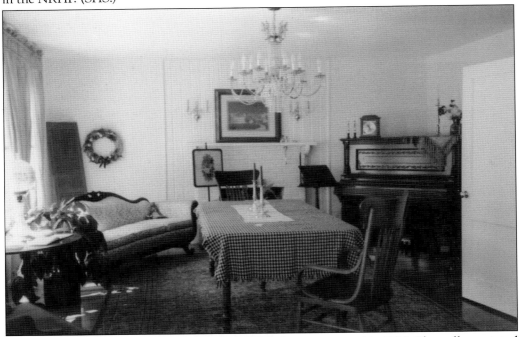

This photograph shows the parlor of the Inn at Salado as it appeared in 1984. The well-appointed parlor is furnished with period pieces from a local antique shop. All pieces in the parlor were available for purchase. When a piece was bought, it was replaced with another item. This gave the parlor a consistently refreshing new look. (SHS.)

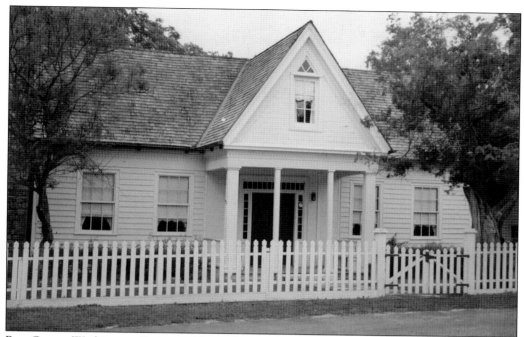

Rev. George Washington Baines and his wife, Cynthia, built this one-and-a-half-story frame house in 1866. Reverend Baines was the third and fifth pastor of the Salado Baptist Church. He also served as pastor to other churches in the area. The house, located on Royal Street, was restored by John B. and Frances Seaberry in 1981. It has a Texas Historical Commission marker and is listed in the NRHP. (Egon Friedrich.)

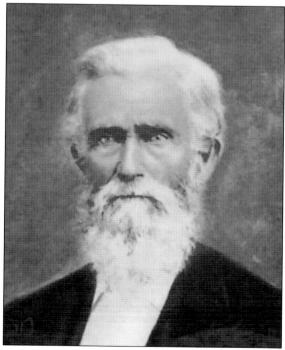

Rev. George Washington Baines came to Texas in 1850. He was known as a wise and peace-loving clergyman. He served as president of Baylor University at Independence from 1861 to 1863. In his later years, he served as president of the board of trustees of the Baylor female college in Belton. The school is now known as the University of Mary Hardin–Baylor. Reverend Baines died in 1882 and is buried in the Old Salado Graveyard. (The Texas Collection, Baylor University, Waco, Texas.)

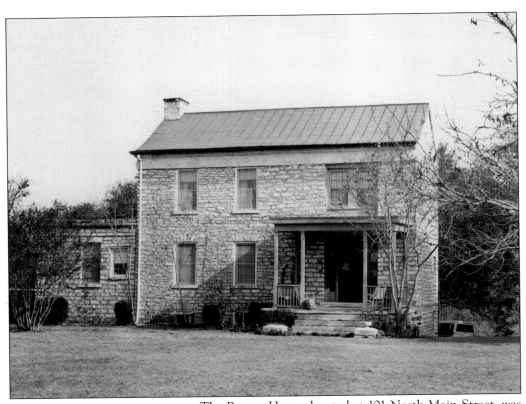

The Barton House, located at 101 North Main Street, was built in 1866 by pioneering physician Dr. Welborn Barton and his wife, Louisa. The three-story structure was constructed of Texas limestone with floors made of longleaf pine. Dr. Barton and his wife reared 10 children in this home. All of the family members were active in the community. The house has a Texas Centennial marker and was placed in the NRHP in 1983. (Egon Friedrich.)

Dr. Welborn Barton received his medical training at Kentucky's Transylvania University. He came to Texas in 1854 and settled in Burnet County, where he practiced medicine. During the Civil War, he served as a surgeon in the Confederate army. After the war, he moved his family to Salado. Barton was a trustee of Salado College and taught the children's Sunday school class at the Baptist church. He died in 1883 and is buried in the Old Salado Graveyard. (Dr. John and Pat Barton.)

Louisa Adeline Cox Barton, born in 1835, married Dr. Welborn Barton in 1850. A nurse, she worked alongside her husband. She was the mother of 10 children and was a leader in the Amasavourian Literary Society of Salado. She died in 1920 and is buried next to her husband in the Old Salado Graveyard. (Dr. John and Pat Barton.)

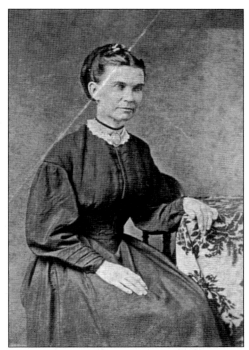

This is the Sam Houston Barton family. Sam Barton was the oldest son of Dr. Welborn and Louisa Barton. Shown here are, from left to right, (seated) Sam Houston Barton (with son Sam Houston Jr., age three) and Nancy Anderson Garrett Barton (holding baby Suzy Corrine, age six months); (standing) Randell (eight years old), William Welborn (twelve years old), and Blakey Reymond (six years old). This photograph was taken in 1890 or 1891. (Dr. John and Pat Barton.)

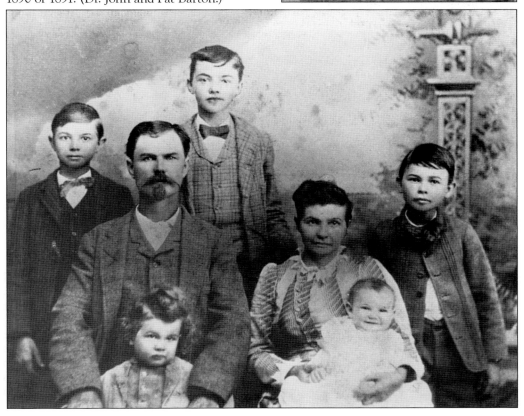

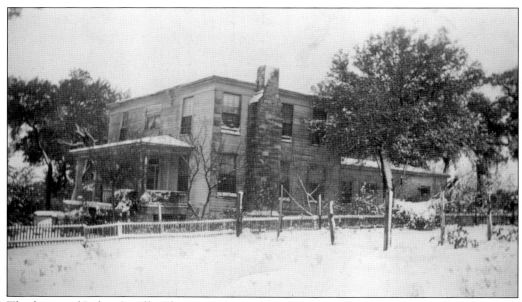

The home of Judge Orville Thomas Tyler and his wife, Caroline Childers, was built by Col. John T. Flint in 1856–1857. It was constructed from lumber hauled by wagon from East Texas. This two-story frame house, one of the first homes in Salado, is on Main Street near the north bank of Salado Creek. This view from the north is one of the earlier photographs of the house. (Sophia Vickrey Ard.)

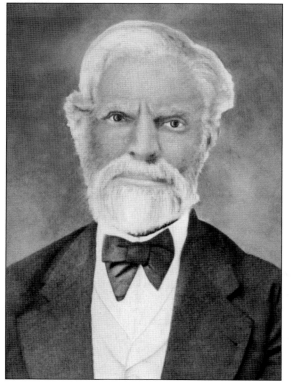

Orville Thomas Tyler was born in Massachusetts in 1810. He sailed to Texas in 1825 and migrated to Central Texas in 1834 where he engaged in farming and ranching. The Tyler family moved to Salado in 1864, where he became involved in church and community affairs. Tyler was known as a pioneer Texan, a county judge, a member of the legislature, and president of the Salado College Board of Trustees. (SHS.)

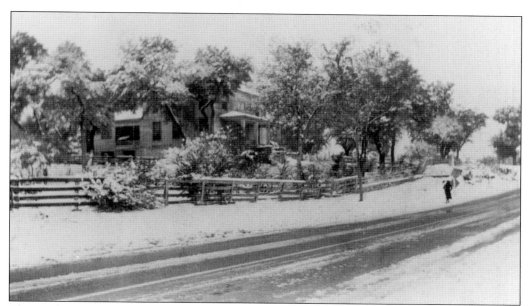

The south side of the Tyler home is seen in this 1940s winter view. A granite marker in front of the house was placed by the State of Texas during the 1936 state centennial celebration. The Tyler house is listed in the National Register of Historic Places. (C.B. and Mary Hodge.)

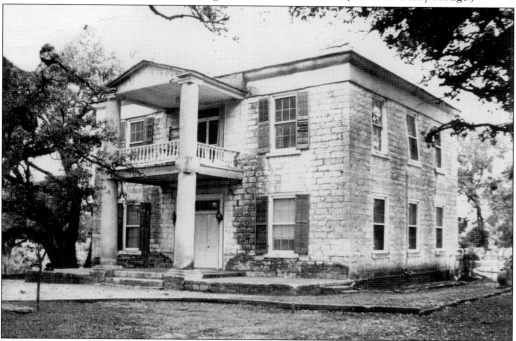

This magnificent Neoclassical, two-story native stone house was built in 1867–1869 by Dr. Benjamin McKie and his wife, Eva. Dr. McKie was a pioneer Central Texas physician who brought his family to Salado so his son could attend Salado College. The house, commonly known as Twelve Oaks, is located at 628 Center Circle. It has a Texas Historical Commission marker and is listed in the NRHP. (Egon Friedrich.)

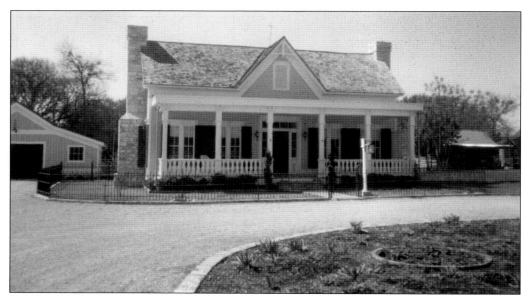

Dr. Samuel Farr, for whom this house is named, purchased the home in 1879. The original version of this 1875 Greek Revival home included two front rooms separated with a dog run, large front and back porches, and a detached kitchen. Subsequent owners have enclosed the dog run and added rooms. The house was moved from Belton to its present location on Rose Way in 1992. The house is listed in the NRHP. (LaVerne Gore.)

John Hendrickson built this board and batten house in 1871. It was home to W.J. and Rebecca Caskey from 1875 to 1909. The Caskeys died in 1909, four days apart. After their deaths, the family sold the house to the Salado Baptist Church, and it was used as a parsonage for 12 years. This house, located on Center Circle, was listed in the NRHP in 1995. (Charlene Carson.)

William Jefferson Caskey was a farmer and a member of the first Grange in Salado. He was involved with the early school board of the Salado free school district, and he also served on the Thomas Arnold High School Board of Trustees. He was a Mason and an active member of the local Baptist church. (Bill and Bonnie Smith.)

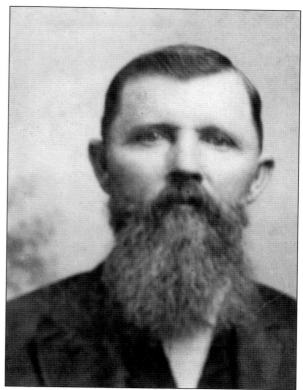

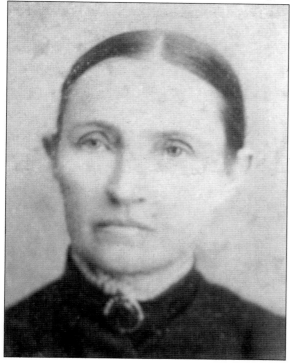

Sarah Rebecca Chapman Caskey was born in June 1840. She married William Jefferson Caskey in Williamson County in September 1857. She was the mother of seven children. The Caskey family moved to Salado so the children could be educated at Salado College. Upon Sarah Rebecca's death in January 1909, a tribute to her stated, "She was a woman nobly planned and born to comfort and command." (Bill and Bonnie Smith.)

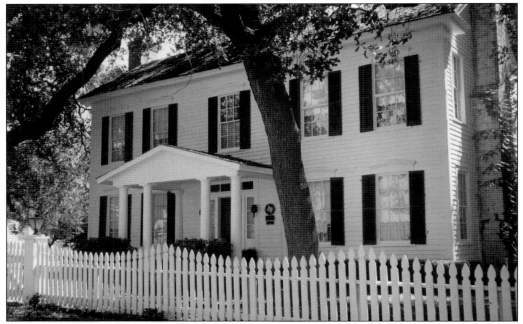

The Fowler house was built in 1872 by Capt. Josiah Fowler and his wife, Rebecca. This imposing two-story Federal home is located at 1301 North Stagecoach Road. The Fowler family came to Salado from Tennessee just after the Civil War. The house has a Texas Historical Commission medallion and is listed in the National Register of Historic Places. (LaVerne Gore.)

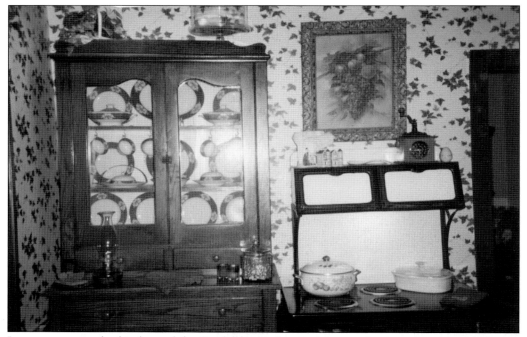

In recent years, the kitchen of the Fowler house featured a reproduction electric stove. It was designed to resemble the old wood-burning stoves of days gone by. (LaVerne Gore.)

Capt. Josiah Fowler was born in July 1811 and died in Salado in July 1888. When he lived in Salado, Captain Fowler taught at Salado College and was coauthor of a highly regarded mathematics textbook, *The Federal Instructor; or Youths Assistant, Containing the Most Concise and Accurate Rules for Performing Operations in Arithmetic*. A copy of the book was recently found at an antique shop in Dallas and was returned to Salado. (LaVerne Gore.)

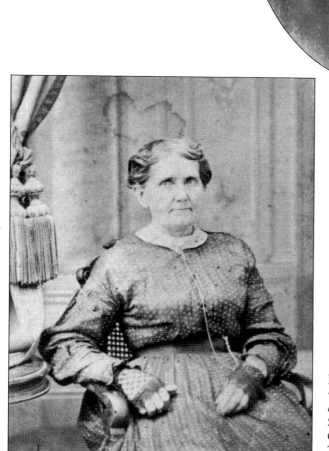

Rebecca McCamey Yett Fowler was born in June 1814 and died in Belton in March 1890. She is buried in the Fowler Cemetery in Burnet County, Texas. (LaVerne Gore.)

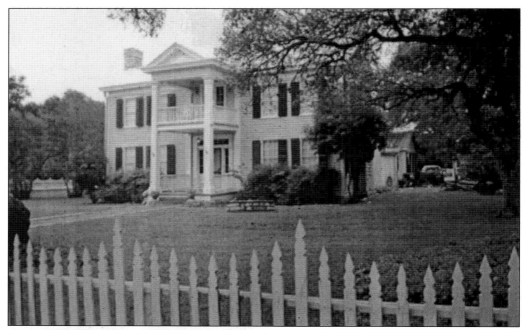

Maj. Archibald J. Rose and his wife, Sarah "Sallie" Ann Austin Rose, moved to Salado in 1870. They chose a country setting for their two-story Greek Revival home. It was in this home, located at 903 Rose Way, that the Roses' children grew up. The family owned and occupied the home for over 100 years. The Rose House received a Texas Historical Commission marker in 1981 and is listed in the NRHP. (Egon Friedrich.)

Louzelle Barclay, granddaughter of Major and Mrs. Rose, and William Lusk, great-great grandson of the Roses, read the newly dedicated historical marker for the Rose House after the dedication ceremony on October 25, 1981. (Egon Friedrich.)

Major Rose, born in 1830, served in the Confederate army, was cofounder of the Texas State Grange and president of the Board of Directors of Texas A&M, and served as a trustee of Salado College and the Salado Public School System and as grand master of the Masonic Order in Texas. Major Rose died in 1903 and is buried in the Old Salado Graveyard. (Charlene Carson.)

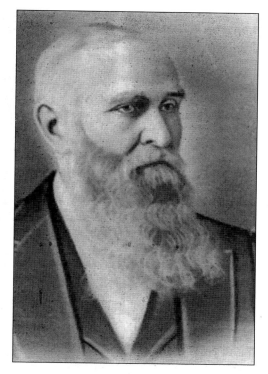

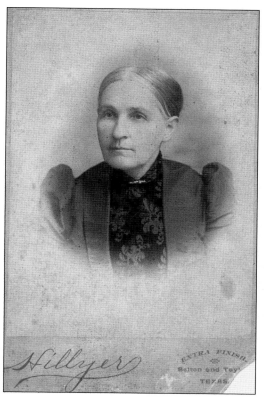

Sarah "Sallie" Ann Austin Rose was born in 1837. She married Archibald Johnson Rose in July 1854 in Macon County, Missouri. She was the mother of 11 children. The family migrated to Texas in 1857. They lived in Travis, Bastrop, and San Saba Counties before settling in Salado. They came to Salado so their children could attend Salado College. Sallie Ann Austin Rose died in 1900 and is buried in the Old Salado Graveyard. (SHS.)

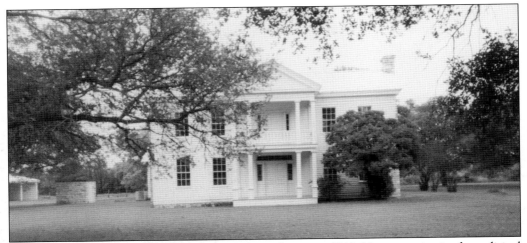

Capt. Robert B. Halley built this two-story frame house in 1860. He was active in the political life of Bell County. During the Civil War, he organized a troop of rangers, known as Halley's Troops. The house, located at 681 North Main Street, is best known as the Halley House, a bed-and-breakfast inn. The house has a Texas Historical Commission marker and is listed in the NRHP. (SHS.)

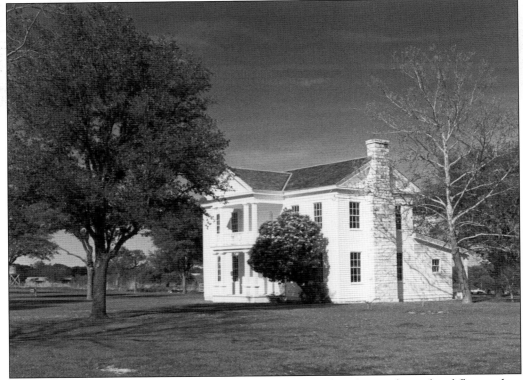

This photograph with a south view of the Halley House was found recently at a local flea market. The photograph had no identification marks, but the finder recognized the structure as the Halley House, bought the photograph, and then gave it to one of this book's coauthors. A former manager of the Halley House Bed and Breakfast dates the photograph to the 1960s. (Charlene Carson.)

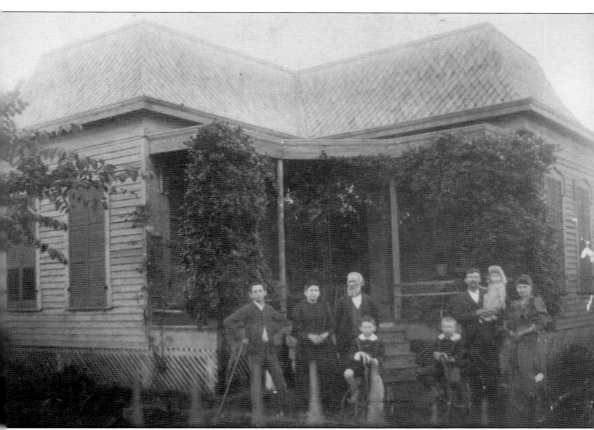

Granville Napoleon Vickrey and his wife, Sophia, built this modest yet charming Victorian home in 1885–1886. The Victorian style was less common than some others in Texas. The house offers an excellent example of a mansard roof. This was the childhood home of Sophia Vickrey Ard, an early historian of Salado. Many of the photographs in this publication are from her collection. The home, located at 402 North Main Street, is included in the National Register of Historic Places. Posing in front of the house are, from left to right, Ralph M. Butler, Sarah Jane (Walden) Butler, Thomas Stuart, Leroy Samuel Butler (on tricycle in front of his father), Loren Stinson Vickrey (on tricycle in front of his father), "Polie" Vickrey (holding Ruby May Vickrey), and Sophia (Stinson) Vickrey. The photograph was taken in front of the original Vickrey house about 1894–1895, before remodeling. (Sophia Vickrey Ard.)

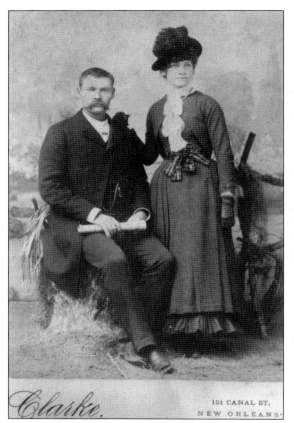

Granville N. Vickrey and Sophia Stinson were married on December 23, 1885. They left Salado the next day for a month-long honeymoon in New Orleans. Their wedding photograph was taken while on their visit to New Orleans. Granville Vickrey was a prominent Salado merchant, and he operated several farms in the area. He and Sophia were active members of the local Baptist church. (Sophia Vickrey Ard.)

This Vickrey family photograph was taken in April 1891 at the golden wedding celebration of Granville Vickrey's parents, John Wright Vickrey and Mary Ann Butler Vickrey. Shown here are, from left to right, (first row) Dr. William Stuart Vickrey, Frank Vickrey, John Wright Vickrey, and Mary Ann Butler Vickrey; (second row) Granville Vickrey, Sarah "Sallie" Vickrey McCure, Allen Jenkins Vickrey, and Mary Ann "Mollie" Vickrey King. (Sophia Vickrey Ard.)

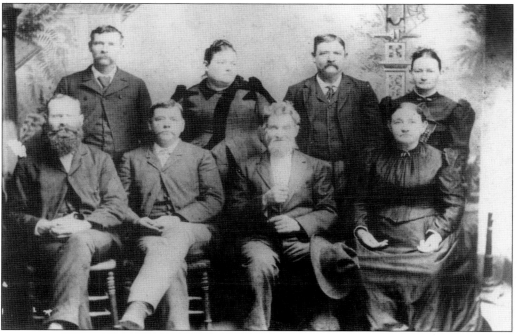

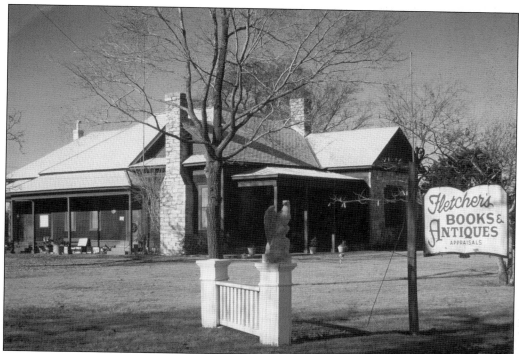

The Vickrey-Berry House, located at 680 North Main Street, was constructed in 1870 by J.W. Vickrey. It was made of hand-cut rock blocks and had walls 20 inches thick. Later, W.R. Berry removed most of the rocks and used them in the construction of some of his other buildings. Home to Fletcher's Books & Antiques during the 1950s, the house received a Texas Historical Commission medallion in 1961. (Tyler Fletcher.)

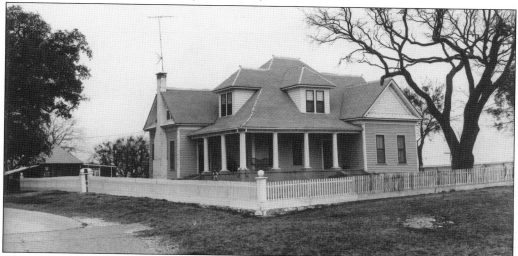

The White-Aiken House is a fine example of a Texas farmhouse. Gus and Emma (Hamblen) White built the house in the early 1900s. It was occupied by two daughters of the Hamblen family. Later, Anna Hamblen and her husband, Carl Aiken, lived in the house for many years. The White-Aiken House has a Texas Historical Commission marker and is listed in the NRHP. (Egon Friedrich.)

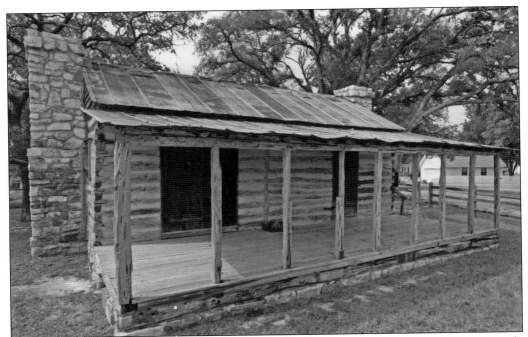

The Boles-Aiken cabin was discovered in 1986 between the walls of a house on Center Circle that was being demolished. The cabin was disassembled, and its logs were carefully numbered and stored until they were acquired by the Salado Historical Society. The cabin was rebuilt at its present location at the Salado Civic Center. The cabin is believed to have been constructed before Salado's founding and has served as a stage stop, post office, and school. (Ryan Hodge.)

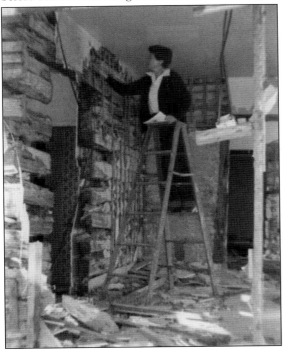

A worker carefully removes the sheetrock walls of the Center Circle house, exposing the logs of a cabin within the house. Several workers spent hundreds of hours working on this restoration project. The restored cabin is currently furnished with appropriate decor, representing its life as a stage stop, post office, and school. (Robert and Doris Denman.)

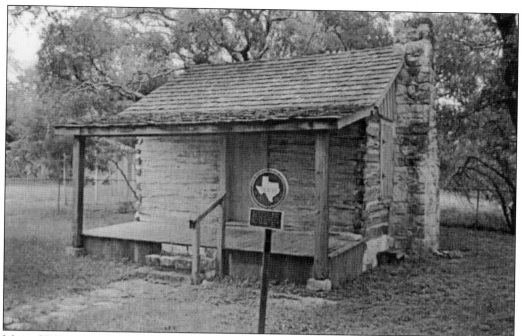

Moses H. Denman built this log cabin in 1867 at Sparta on the Cowhouse Creek. The cabin has hand-hewn square cedar logs joined with wooden pegs and a fireplace of native stone. When Robert and Doris Denman purchased the cabin, they moved it, first to their Salado homesite and then to its current location behind the Salado Civic Center. The cabin received a Texas Historical Commission medallion in 1968. (Maurice Carson.)

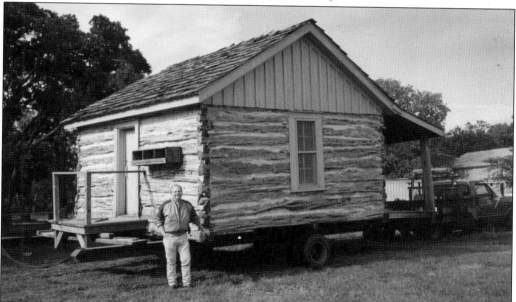

Robert Denman stands next to the Denman Cabin as it waits to be unloaded at its new location on the Salado Civic Center grounds, situated at the corner of Main and Van Bibber Streets. The cabin is complete with a front porch, back steps, and a chicken coop. (LaVerne Gore.)

This sketch by an unknown artist captures the essence of the Stagecoach Inn as it appeared in the late 1800s. Begun in 1852 to serve travelers along the old stage route, the Stagecoach Inn is the longest continuously operating hotel in the state, and it is thought to be the oldest remaining structure in Salado. The hotel has had several names and owners through the years.

The name *Stagecoach Inn* was adopted in 1943, the year Dion and Ruth Van Bibber opened their world-renowned dining room. The inn has received a Texas Historical Commission marker and is listed in the NRHP. (SHS.)

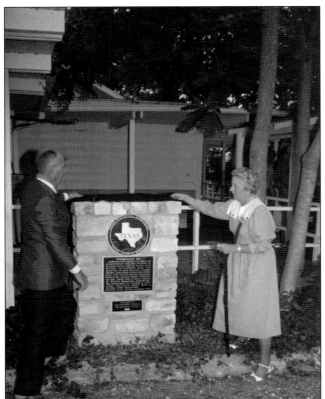

In 1985, the Stagecoach Inn received a Texas Historical Commission replacement marker and a National Register of Historic Places plaque. These markers replaced the original 1962 medallion and plaque that had disappeared. William and Betty Bratton, shown here, owned and developed the Stagecoach Inn from 1959 to 1999. (SHS.)

Rev. Levi Tenney, a Presbyterian minister and first president of Salado College, built this Greek Revival home in 1859–1860. The house features thick walls made of native limestone. The long, narrow slits in the front rock walls are gun slits. They were used to protect the occupants from Indian attacks. The Tenney House, located at 100 Pace Park Road, is listed in the NRHP. (Egon Friedrich.)

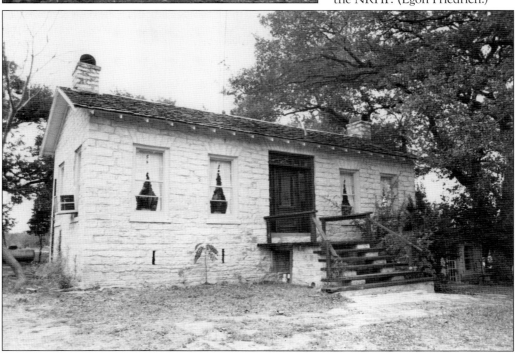

Seven

RELIGION AND EDUCATION

"Give me that ole time religion," is a phrase that best describes the religious heritage of the Village of Salado. Long before there were church buildings, the people of Salado attended services in brush arbors along the banks of Salado Creek. Most of the early families of Salado were religious and fairly well educated, and they wanted their children to have the benefits of good churches, good schools, and good society.

After Salado College was established, the Baptist, Methodists, Cumberland Presbyterians, and Church of Christ congregants began meeting in a union Sunday school in the college chapel. In a short time, each of the four groups alternated having an all-day Sunday service in the chapel. This enabled each denomination to have a monthly service. The Primitive Baptists met at the college chapel every fifth Sunday.

As time went by and the congregations grew, one by one, they left the college to erect their own church buildings. The three historical congregations—Methodist, Church of Christ, and Baptist—have been joined by several other congregations of believers. The old-time religion of Salado lives on.

Education was the major contributing factor in the founding and early growth of Salado. When plans for the formation for Salado College were announced, families moved to Salado so their children could be educated at the college. When the school's charter expired, quality education continued at the prestigious Thomas Arnold High School.

Salado had a public free school system as early as 1874. This school was in a three-room house due west of the O.T. Tyler House. In 1918, the public free school moved into the college building, and schooling continued there until the fire of 1924, which destroyed the building. After the fire, a new school was built at a site on Main Street, several blocks north of the college.

Currently, the elementary, intermediate, and junior high schools are located on Thomas Arnold Road. The Salado High School, built in 2008, is located at the corner of Williams Road and FM 2484. All of the schools offer a quality education to the children of the Salado Independent School District.

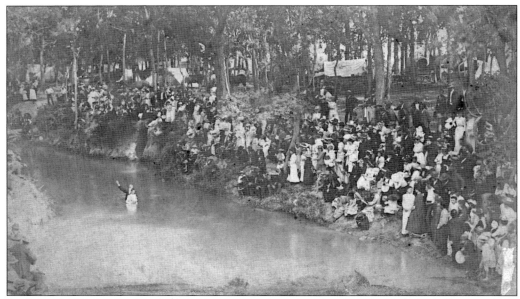

In the early days, most church services were conducted in the chapel of Salado College or along the banks of Salado Creek. This photograph shows a baptismal service following a 16-day camp meeting conducted by Maj. W.E. Penn in 1879. Penn was the first full-time evangelist in the state of Texas. After the service, 180 new converts were baptized in the creek. (Sophia Vickrey Ard.)

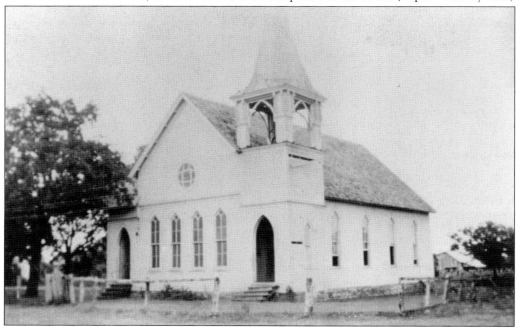

The congregation of the Salado United Methodist Church first met in 1854 at Pecan Grove, on the north side of Salado Creek. Later, the congregation moved to the chapel of Salado College. In 1890, this Carpenter Gothic church was built at the corner of Thomas Arnold Road and Church Street. The church has a Texas Historical Commission marker and is listed in the NRHP. (Procter and Prudie Capps.)

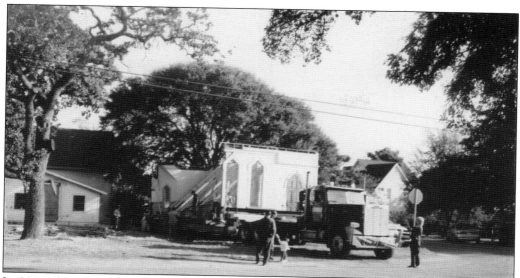

In 2001, the Methodist congregation decided to move to a larger property, where they could build a new sanctuary. After voting to move the historic church building to the new property, a professional moving company was hired to transport the building. In order to be relocated, the building had to be taken apart. This photograph shows one section of the building loaded and ready for moving. (C.B. and Mary Hodge.)

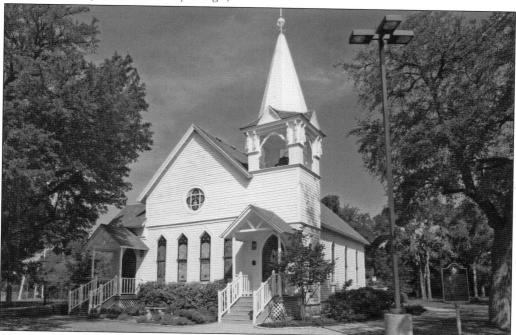

The 1890 building was safely moved to its new location on Royal Street and successfully restored. As a result of its relocation, the church lost the right to display its historical marker. Church member Pat Barton researched the congregation, and in 2005, a Texas Historical Commission marker commemorating the church was placed in front of the newly restored building. The church recently added a columbarium in the garden behind the chapel. (Ryan Hodge.)

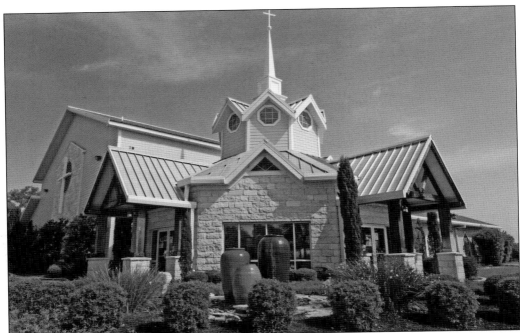

The new sanctuary of the Salado United Methodist Church is located on a beautifully wooded 15-acre site on the eastern edge of Salado. These facilities were completed in 2005. (Ryan Hodge.)

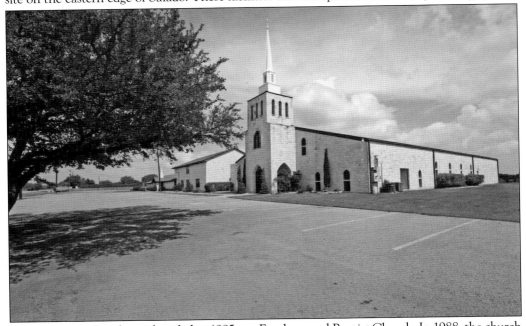

Grace Baptist Church was founded in 1985 as a Fundamental Baptist Church. In 1988, the church purchased land on FM 2484 and erected its first building. Later, the church reorganized as a Southern Baptist Church, and in 1999, it became affiliated with the Southern Baptists of Texas Convention. In the last few years, the church has acquired additional land and has completed an extensive building program, including the present sanctuary. (Ryan Hodge.)

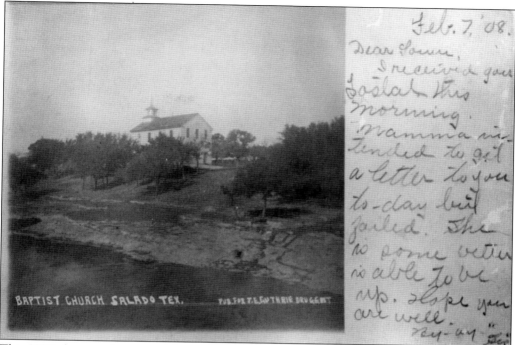

This 1908 photograph postcard features the Salado Baptist Church of Christ (now First Baptist Church). The congregation, which began in the chapel of Salado College in 1864, erected this humble building in 1878 on a lot donated to the church by Judge O.T. Tyler, located on the north bank of Salado Creek. (Sophia Vickrey Ard.)

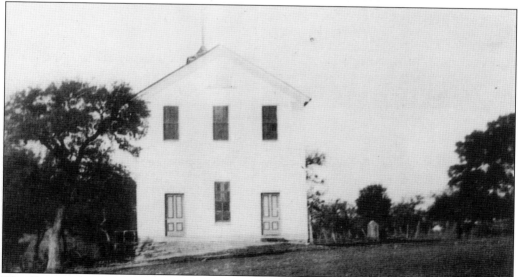

This Baptist church building was erected jointly with the Masonic lodge in 1878. The church met on the bottom floor, and the lodge met on the second floor. In 1958, the congregation built a new sanctuary. The original building, seen here in the 1940s, was dismantled in the early 1960s. The upper half was literally sawed off and moved to its current location on Church Street, where the lodge continues to meet. (Doodle Bridges.)

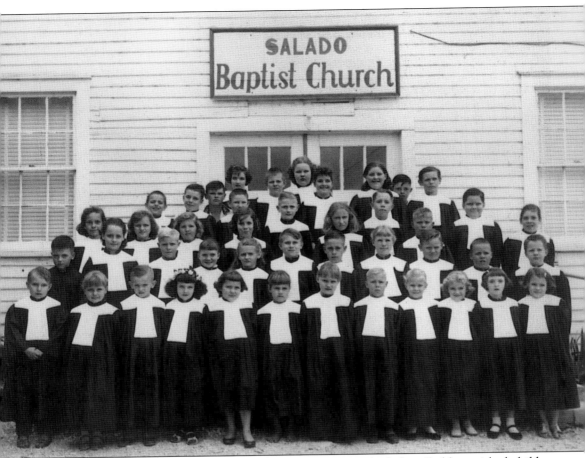

Choir director Ruby Vickrey Hutchens, or "Miss Ruby," as the kids called her, picked children up at school in her Model T and brought them to the Baptist church for after-school choir. Eula Turland Splittgerber was the pianist. The Salado Baptist Church Children's Choir poses in 1957. Shown here are, from left to right, (first row) William McDowell, Sherry Tabor Jackson, David Friedrich, Linda Friedrich Cawthon, Judy Arnold Houston, Linda Grimm Moore, Kathy Hess, Donald Lucas, Dorothy Lucan Phipps, Zendal Lindsey, Peggy Huey Warren, and Sharlene Lott; (second row) Ronnie Carroll, Kitty Williams Pevey, Alvin Lucas, Dovie Marie Lang, Polly Love, C.B. McDowell, Lee Grimm, Rita Splittgerber Hohle, Stanley Guinn Williams, Freddie Fuller, and Charles Evans; (third row) Margie Grimm, Sandy Evans Scully, Sharon Fuller, Mary Brown, Sue McDowell, and Jerry Lucas; (fourth row) Travis Kinsey, Kent Townsend, Bennie Brooks, Jody Arnold, Mark Peteete, Tommy Brown, Berry Evans, and Charlotte Ickes; (fifth row) William Splittgerber, Linda Kay Wolff, Bobbie Pierce, and Allen Love; (sixth row) Betty Huey Croftcheck, Mary McHam Ribiero, and Billy Carroll. (Eula Turland Splittgerber.)

A new Salado First Baptist Church worship center was dedicated on May 6, 2001. Also on that date, the church dedicated a Texas Historical Commission marker commemorating the men and women who founded the church on May 28, 1864. (Charlene Carson.)

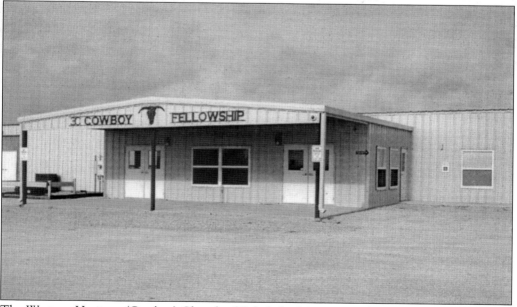

The Western Heritage (Cowboy) Church of Salado had its start in August 2005, with the First Baptist Church serving as a lead sponsoring church. The newly formed fellowship adopted the name 3C Cowboy Fellowship. It held its first weekend service on April 16, 2006. The church facilities are located just south of Salado on Gooseneck Road. The church is reported to be one of the fastest-growing congregations in the area. (Maurice Carson.)

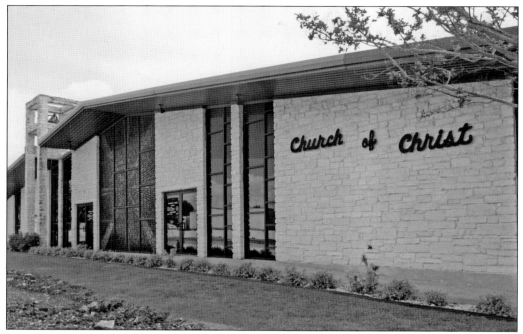

Founded in 1859, the Salado Church of Christ first met in a brush arbor on the north bank of Salado Creek. The congregation erected its first building on North Main Street in 1875. The structure burned down in 1908. A second building served the congregation until 1961, when a brick sanctuary was erected. The present building was completed in 1988. A Texas Historical Commission marker commemorates the history of the church. (Ryan Hodge.)

Dr. Carroll Kendrick (1815–1891) was a charter member of the Church of Christ. He served on the first board of trustees of Salado College, and he was a physician, educator, writer, and evangelist. (SHS.)

St. Stephen Catholic Church began in 1988–1989 as St. Stephen Mission and Parish with nine founding families. The first mass was celebrated on Mother's Day 1989 at Tablerock Amphitheater. Within the next 12 months, the diocese purchased a tract of land on Holland Road for the church, and a series of building programs soon followed. The church continues to grow under the leadership and enthusiasm of the current pastor. (Ryan Hodge.)

For years, Tyler Fletcher, youth director of St. Luke's Episcopal Church in Belton, dreamt of having a chapel in Salado. Finally, in 1995, he converted a storage shed behind Fletcher's Books & Antiques into a tiny chapel. Among its furnishings are four antique pews from St. Luke's Church and a simple altar. On March 20, 1999, St. Joseph's Episcopal Chapel was dedicated as a parish mission of St. Luke's. (Ryan Hodge.)

The Presbyterian Church of Salado was founded on October 5, 1997, with 32 confessing members and 5 baptized children. The congregation worshipped in Allen Hall, behind Inn of Salado, until December 2000, when it moved to its current location at 105 Salado Plaza Drive. The growing congregation celebrated the church's 15th anniversary in September 2012. (Maurice Carson.)

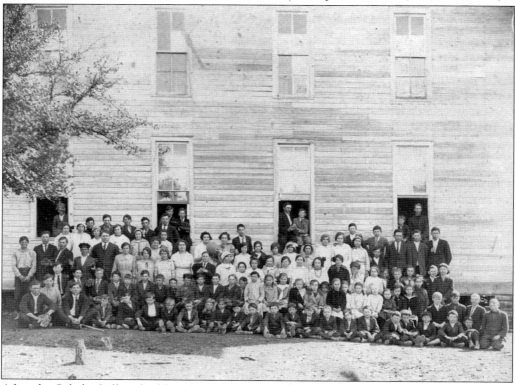

After the Salado College building fires, the students were divided by grade levels and attended classes at the three Salado churches—the Baptist, Methodist, and Church of Christ—until a new school could be built. This is a photograph of the entire faculty and student body of the Salado Public School System. The structure is the old Baptist church. (Enis Miller.)

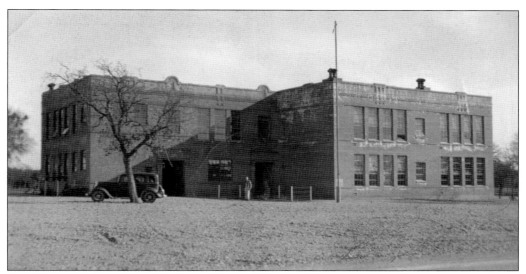

In 1924, Alice Gray Hamblen donated her four-and-a-half-acre family homesite to the Salado public schools. Classroom space was an urgent need, as Salado College had burned down for the third time and would not be rebuilt. The family home was torn down, and construction of the Salado Public School building began immediately. Alice Hamblen made the donation in memory of her husband, William K. Hamblen. (Carolyn Lamberth Johnson.)

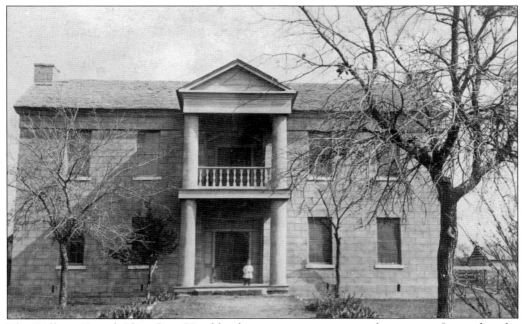

The William K. and Alice Gray Hamblen home was a two-story rock structure. It stood at the site of the present-day civic center building. William Hamblen was a Church of Christ minister, trustee of Salado schools for 20 years, and trustee of Salado College. He died in 1902 and was buried in the family cemetery, located on the grounds of their family home. (SHS.)

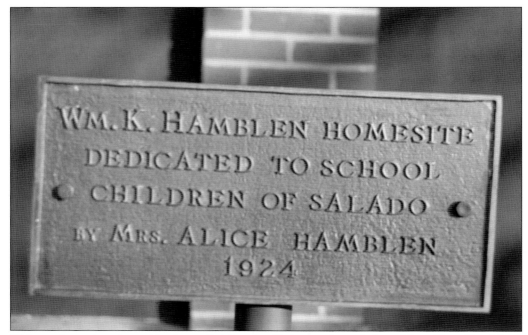

This marker, placed outside the redbrick schoolhouse, acknowledges Alice Gray Hamblen's donation to the Salado Public Schools. Hamblen died in 1932 and was buried next to her husband in the family cemetery. (SHS.)

This is a photograph of the Hamblen sisters, the daughters of William K. and Alice Gray Hamblen. They are, from left to right, (seated) Vesta Hamblen, Alice Hamblen Potter, Ella Hamblen Manning, and Emma Hamblen White; (standing) Annie Hamblen Aiken and Naomi Hamblen Hughes. (SHS.)

C.O. Boatman was the Salado High School superintendent in 1924, when the red brick school opened. Brother Boatman was also pastor of the Salado Methodist Church. The Halley House can be seen in the background. (Sophia Vickrey Ard.)

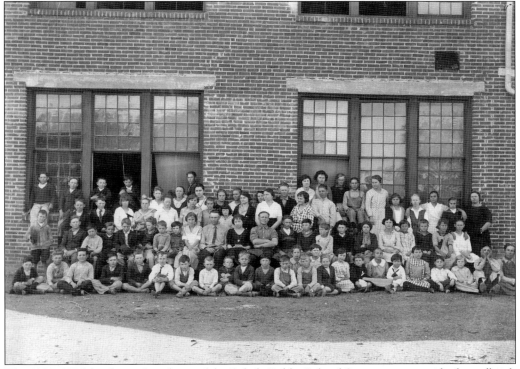

The 1924–1925 faculty and students of the Salado Public School System pose outside the redbrick school building for a school photograph. This is the first group to have met in the redbrick schoolhouse. (Ruth Miller.)

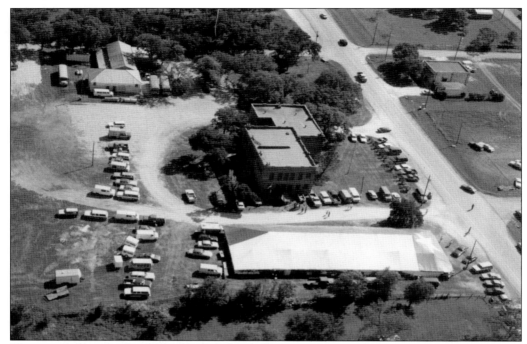

This aerial photograph of the 1991 Salado Bluebonnet Antique Show offers a good view of the Salado Public School grounds. The agriculture barn and the bus barn can be seen in the upper left. (SHS.)

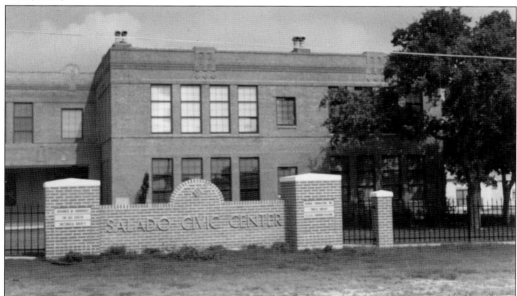

This redbrick building, erected in 1924, housed the entire school system until Thomas Arnold Elementary was opened in 1967. The high school students remained at the redbrick building until 1979, when a new high school was opened on Thomas Arnold Road. In 1993, the old redbrick schoolhouse, after being abandoned for almost 15 years, was renovated and dedicated for use as the Salado Civic Center. (SHS.)

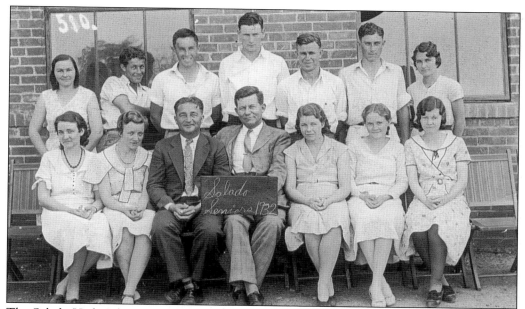

The Salado High School class of 1932 poses outside the old redbrick schoolhouse for its senior picture. Shown here are, from left to right, (first row) Edith Allamon, Clara Berry, Mr. Coston (coach), unidentified, Freda Norwood, unidentified, and Christine Porter; (second row) ? Moran, four unidentified students, Proctor Capps, and Lillian Townsend. (Freda Norwood.)

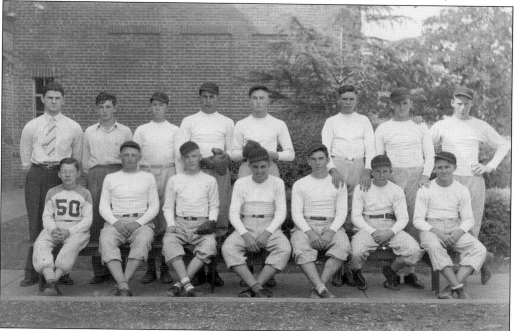

Salado High School had an outstanding baseball team in 1941. Posing here are, from left to right, (first row) C.W. Baker, J.C. Warrick, Everett Baker, Kenneth Townsend, Albert Pustejouasky, Leroy Magill, and William Ingram; (second row) Henry L. Graves (coach), William Street, J.D. Hinsley, J.D. Nixon, R.L. England, John Fox, R.B. Hutchinson, and John King Robinson. (SHS.)

The Salado class of 1944 posed for a photograph in the stairway of the old redbrick schoolhouse. Shown here are, from left to right, (first row) Supt. Frank Kraner, Louise King, Alfred Smith, Arnell Havens, C.B. Hodge, and Labera Caskey (class sponsor); (second row) Claude Robbins, Mozelle Ray, Darrell Webb, and Harvel Havens; (third row) Ramah McQuire, Troy Alton Martin, and Tommy Moron. (C.B. and Mary Hodge.)

The first-grade classes of the 1950s met in what was the Salado Historical Society meeting room. This is the first-grade class of 1957–1958. (Linda Cawthon.)

The 1948–1949 Salado first and second grades consisted of forty students, one teacher, and one dog. Pictured here are, from left to right, (first row) Wayne Kamman, Jeffery Pyle, Wilburn Drake, Martin Torres, and Roy Dean Hunter; (second row) Hollis Hunter, Joe Copeland, Linda Sue Gidley, Donnie Copeland, Jessie Torris, Alice Lang, Jack Evans, Jerry England, Weeta Sue Holland, Jean Brinegar, and Virgie Grimm; (third row) Daryl Guess, Jimmie Nell Daniels, Joyce Holden, Jane Lisenbe, George Lang, Darrel Wright, Sharon Buchanan, Sue Cowen, Isaias Canaro, Ellis Canaro, and Kenneth Blair; (fourth row) Roger Symes, Dicksy Herrington, Tommy Lisenbe, Franciso Lopez, Charolette Gibbs, Darlene Reed, Jimmie England, Gary Pedigo, Kenneth Parker, Jill Schultz, Romona Guajarda, Mary Norwood, Bettie Sue Sutton, and teacher Lucille Rosser. (Weeta Evans.)

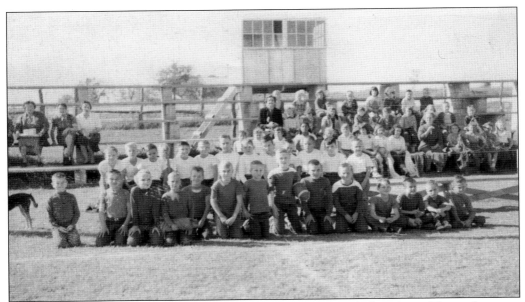

Most of the school's outdoor activities took place at the old football stadium. The stadium was located north of the redbrick schoolhouse and west of Main Street. Many football games, egg hunts, and athletic events were held at the stadium from 1948 to the 1970s. (C.B. and Mary Hodge.)

The Salado High School class favorites for the 1960 school year are shown in this photograph. Pictured are, from left to right, Charles Huey and Marie Dunlap, most athletic; Floyd Crews and Ajuan Rhodes, Mr. and Miss Personality; LaNell Rose and Gaylon Adams, Mr. and Miss SHS; and Weeta Sue Holland and Lynn Vaden, most beautiful and most handsome. (Weeta Evans.)

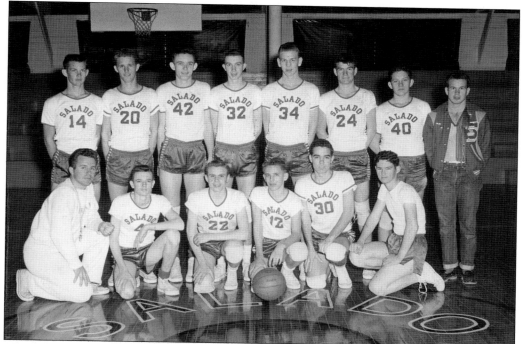

The 1960 Salado High School boys' basketball team poses for a photograph. Shown here are, from left to right, (first row) coach Paul Burke, Winston Kinsey, Daryl Guess, Darrell Musick, Floyd Crews, and Bruce Townsend; (second row) Gaylon Adams, Lynn Vaden, Charles Huey, Hal Ray Copeland, David Musick, Travis Morris, Jack Evans, and Drew Jackson. (Weeta Evans.)

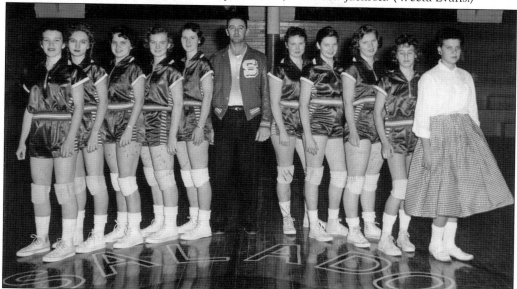

The 1960 Salado High School girls' basketball team gathers for a photograph. Pictured here are, from left to right, Claudia Cabiness, Jill Schultz, Yvonne McDonald, LaNell Rose, Weeta Sue Holland, coach Royce Swaim, Tony Petterson, Lois Petterson, Marie Dunlap, Virgie Grimm, and manager Faye Walker. (Weeta Evans.)

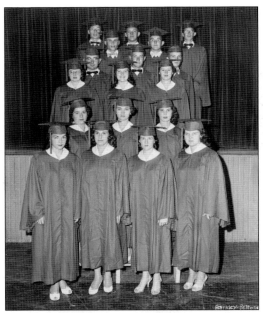

This is the 1960 senior class. Posing are, from left to right, (first row) Mary Casey, Virgie Grimm, Jean Brineger, and Alice Lang; (second row) Elizabeth Cockrell, Jill Schultz, and Linda Berry; (third row) Betty Sue Sutton, Lois Peterson, and Weeta Sue Holland; (fourth row) Jerry England, Bobby Luther, and Prater Gibbs; (fifth row) Daryl Guess and Wayne Kammon; (sixth row) Donnie Coupland, Jack Evans, and Sheril Elms. (Weeta Evans.)

These girls, members of the choral group, are singing at the veterans' home in Temple, Texas. They are, from left to right, Michelle Nidositko, Linda Friedrich, Lyndal Barrett, Brenda Barrett, and Peggy Huey. (Linda Cawthon.)

Thomas Arnold Elementary School was constructed in 1967 on land purchased from the J.H. Caskey family. It is located at 510 Thomas Arnold Road. The Caskey family asked that the school be named Thomas Arnold in honor of Thomas Arnold High School, where family members had attended in the old Salado College building. The school now serves as the campus for prekindergarten through second grade. (Ryan Hodge.)

Salado Intermediate School was constructed in 1996 at 550 Thomas Arnold Road. Today, it serves grades three through six. (Ryan Hodge.)

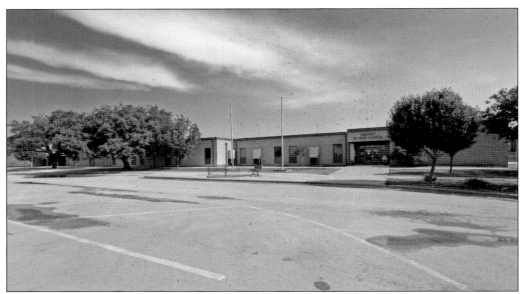

Salado Junior High School was opened in the fall of 1979 as Salado High School. US congressman Marvin Leath was the speaker at the dedication ceremony, which was held on October 14, 1979. The school, located at 620 Thomas Arnold Road, served as the junior high and high school campus until a new high school facility was opened in 2008. Today, it is the seventh-grade and eighth-grade campus. (Ryan Hodge.)

In 2004, the Salado Independent School District purchased 50 acres of the Aiken property, situated at the corner of FM 2484 and Williams Drive, for the purpose of constructing a new high school. The new Salado High School held its grand opening and dedication on August 23, 2008. The school is located at 1880 Williams Road and serves students in grades nine through twelve. (Ryan Hodge.)

Eight

FLAVORFUL AND COLORFUL EVENTS

Salado, founded with a college, offered education and culture. However, from the village's beginning, it is how people entertained themselves that gave Salado its personality. In the early days, entertainment took the form of literary societies, debate clubs, and church socials. A baptismal service in the creek was both a spiritual and a social occasion.

During the 1950s and 1960s, students and teachers went outside together for recess. The kids played games like Farmer in the Dell, Drop the Handkerchief, London Bridge, and Red Rover. The older students would get a game of baseball going, always under the watchful eye of the teacher. Teenagers went bowling, played miniature golf, saw a movie at the drive-in, ate pizza, and hung around at the Dairy Queen in Belton.

Later, plays, dramas, and musical events were held at an outdoor theater. Other outdoor events included potluck suppers, Fourth of July picnics, the Gathering of the Scottish Clans and Highland Games, the annual Christmas Parade and Stroll, and the Christmas Tour of Homes. Today, people can go to an art show, art fair, or art gallery. One can shop for jewelry, the latest fashions, handmade crafts, or home-decor items. Residents and visitors can sample cheese and chocolates, browse through a stack of new, used, and out-of-print books at the local bookstore, or visit the local library.

One of the most enjoyed and well-attended events in Salado is the Salado Reunion, held every June. Anyone who has ever lived in Salado is invited to attend. Some remember attending the reunion when it was held in the backyard of the Robertson Plantation. Present-day reunions are usually held at the Salado Intermediate School auditorium.

Salado has always offered a variety of events for everyone in the family, and it seems that most of the events start with a parade. There is a lot to celebrate in Salado.

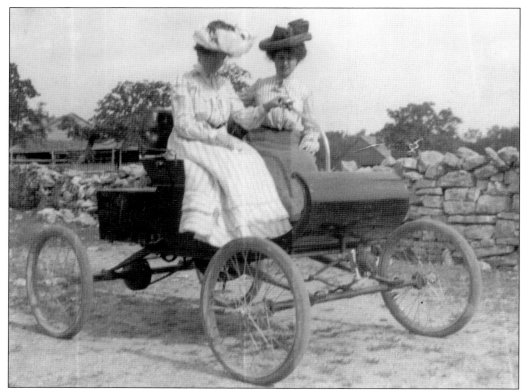

In the early 1900s, two unidentified women take a ride in Salado's first horseless carriage. This automobile was made from a kit ordered by Salado physician Dr. F.G. Kimbrough and assembled by local blacksmith Rye Barber. (Sophia Vickrey Ard.)

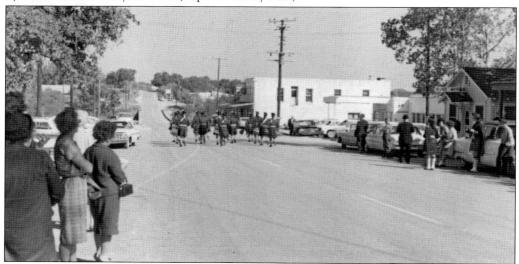

The Scots march down Main Street during their annual Gathering of the Scottish Clans and Highland Games on a fall day in the 1950s. The year 2013 marked the 52nd year that the Scots gathered in Salado for this annual event. It is sponsored by the Central Texas Area Museum. Note the post office on the east side of the street. (C.B. and Mary Hodge.)

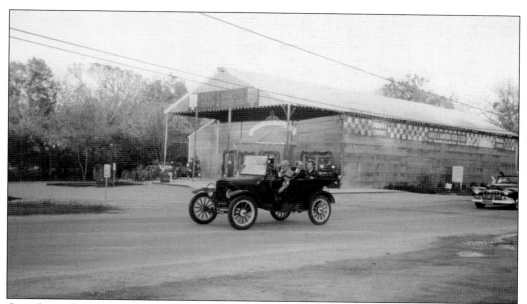

Grand marshals Paul and Patsy Guest Sanford ride in style during the 2004 Christmas Parade. They are seen here passing the former Guest & Sanford Feed & Seed store. The annual Christmas Parade, Christmas Stroll, and Tour of Homes draw hundreds of visitors to Salado during the holiday season. (Pat Barton.)

Three Methodist women ride the Good Time Carriage to their new sanctuary on Royal Street. In 2005, when the Methodist congregation moved to its new location on Royal Street, the members walked from the old site to the new location. These three women were offered a carriage ride. The women are, from left to right, Johnnie Barrett, Jo Glass, and Mary Hodge. (C.B. and Mary Hodge.)

Shown here are attendees of the 1956 Salado Reunion. Among those gathered here are, from left to right (first row), ten unidentified attendees, E.E Griffith, Nannie Griffith, and Louis Griffith; (second row) two unidentified attendees, Georgia Allmon, Minnie Allmon, Nellie Lancaster, Wilson Willingham, Kate and Jay Burris, three unidentified attendees, and Thelma Griffith; (third row) one unidentified attendee, Mrs. Aussie Watson, Sallie and A.W. Capps, three unidentified attendees, Ruth Brown, three unidentified attendees, and Bernice Hodge; (fourth row) Preston Stanford, Bert Johnson, and Edna Barton. (Doodle Bridges.)

Egon Friedrich was elected president of the Salado Reunion in June 1989. After retiring from farming, Friedrich studied photography through a set of books he purchased. He took photography courses at the Cultural Arts Center in Temple and became a member of the Temple Camera Club. For years, he volunteered his services as the official photographer for Salado events. (Linda Cawthon.)

Members of the Salado High School class of 1968 who attended the Salado Reunion in 2008 are, from left to right, Dennis Cabaniss, Howell Cearley, Karen (Smith) Elms, Fred Fuller, Cecil Cosper, and Virginia Cosper. (Linda Cawthon.)

The Salado Sculpture Garden is an outdoor space situated in a natural environment. Its quiet walkways are lined with sculptures created by a diverse group of local and regional artists. Visitors to the garden can view art made from a variety of materials, including iron, stone, bronze, glass, and steel. The purpose of the garden is to integrate art into the daily lives of residents and visitors to the community. (Maurice Carson.)

The Goodnight Tablerock Amphitheater is an outdoor setting for musical and theatrical events, including long-standing productions of *A Christmas Carol* and *Salado Legends*. The land for the amphitheater was donated by Dr. and Mrs. C.D. Goodnight and their daughter Sheryl. (Maurice Carson.)

Actors on the stage of the Tablerock Amphitheater present the story of the settlement of Salado and Bell County. *Salado Legends* is the only outdoor drama in the state chosen by the Library of Congress to serve as a record of life in America at the end of the 20th century. (C.B. and Mary Hodge.)

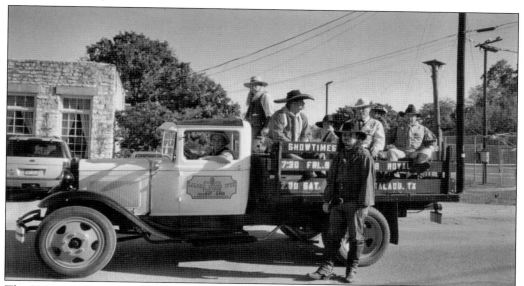

The 2009 Salado Heritage Weekend Founder's Day Celebration, commemorating the founding of Salado College, started with a parade down Main Street. Activities for the day included a cattle drive down Main Street, historical walks and lectures, a ranch rodeo, heritage crafts, and a tour of the Robertson Plantation. The Salado Spur Theater truck is being driven by Grainger Esch, director and theater owner. (Pat Barton.)

Wildfire Ranch opens its doors to some of the biggest names in professional rodeo. The indoor facility comprises 200,000 square feet under one roof. It is home to numerous rodeo events, including the nationally renowned Wildfire Open and the World Team Roping and the Ladies Open Championship. Wildfire Ranch also hosts youth calf roping, Texas senior professional rodeos, and benefit and church roping events. (Maurice Carson.)

DISCOVER THOUSANDS OF LOCAL HISTORY BOOKS
FEATURING MILLIONS OF VINTAGE IMAGES

Arcadia Publishing, the leading local history publisher in the United States, is committed to making history accessible and meaningful through publishing books that celebrate and preserve the heritage of America's people and places.

Find more books like this at
www.arcadiapublishing.com

Search for your hometown history, your old stomping grounds, and even your favorite sports team.

Consistent with our mission to preserve history on a local level, this book was printed in South Carolina on American-made paper and manufactured entirely in the United States. Products carrying the accredited Forest Stewardship Council (FSC) label are printed on 100 percent FSC-certified paper.